W9-ATY-562

★ SUBPAR PARKS

AMERICA'S
MOST EXTRAORDINARY

National Parks

-&-

Their Least Impressed
Visitors

SUBPAR PARKS

AMBER SHARE

PLUME

PLUME

An imprint of Penguin Random House LLC
penguinrandomhouse.com

Copyright © 2021 by Amber Share
Penguin supports copyright. Copyright fuels creativity, encourages
diverse voices, promotes free speech, and creates a vibrant culture.
Thank you for buying an authorized edition of this book and for complying
with copyright laws by not reproducing, scanning, or distributing any part of it
in any form without permission. You are supporting writers and allowing
Penguin to continue to publish books for every reader.

PLUME is a registered trademark and the P colophon is a trademark of
Penguin Random House LLC.

Art courtesy of the author

LIBRARY OF CONGRESS CATALOGING-IN-PUBLICATION DATA
Names: Share, Amber, author.
Title: Subpar parks: America's most extraordinary national parks
 and their least impressed visitors / Amber Share.
Description: [New York] : Plume, Penguin Random House LLC, [2021]
Identifiers: LCCN 2021009779 (print) | LCCN 2021009780 (ebook) |
 ISBN 9780593185544 (hardcover) | ISBN 9780593185551 (ebook)
Subjects: LCSH: National parks and reserves—United States. |
 National parks and reserves—Public use—United States. |
 National parks and reserves—Complaints against—United States—Humor.
Classification: LCC E160 .S495 2021 (print) | LCC E160 (ebook) |
 DDC 973—dc23
LC record available at https://lccn.loc.gov/2021009779
LC ebook record available at https://lccn.loc.gov/2021009780

Printed in the United States of America
8th Printing

BOOK DESIGN BY LORIE PAGNOZZI

For my parents, without whom I wouldn't have my love for the parks, my sense of humor, or my interest in art.

For my husband, who holds my hand and leaps into the unknown with me regularly.

And for my friends and family, who are always ready to help me even when I'm reluctant to accept it.

NO ONE ACHIEVES ANYTHING ALONE.

CONTENTS

MIDWEST ✦

SOUTHEAST ✦

NORTHEAST AND NATIONAL CAPITAL ✦

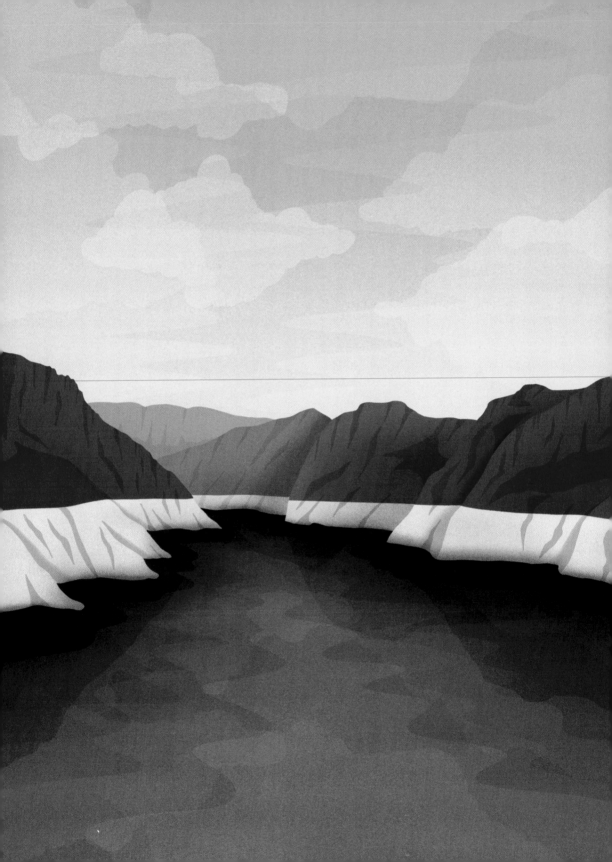

INTRODUCTION /
BEHIND THE SCENES

On July 12, 1999, on a cross-country road trip from California to New Jersey, our family minivan pulled up to the South Rim of the Grand Canyon. A rambunctious and curious ten-year-old, I was instantly transfixed, bursting with questions. What was this place? How did it exist? What made it? What's at the bottom? I poked my head between two bars of the railing, there to keep tourists a safe distance from the edge of the canyon, to try to see a bit better, and I was so engrossed by the endless layers of rock stretching out in front of me that, forgetting my positioning, I cracked my head into the railing when I stood back up. Even though it was rainy and foggy, we spent a few glorious days exploring the rim, and I was fascinated. Twenty-some years later, I would learn that someone else looked at the place that immediately captured my attention and saw it only as "a very, very large hole."

I first discovered there were one-star reviews of our national parks through a Reddit post, and I didn't know whether to laugh or cry. I couldn't understand how someone could look at the same wonders of nature as I and feel so underwhelmed.

Like many people, I consider the parks an integral part of my childhood. We were a Navy family, and my parents would take me, my older brother, and my younger sister to national parks wherever we went, exploring the Great Smokies, the Everglades, the Badlands, Congaree, Mammoth Cave, and Haleakalā, to name a few. I was a proud Junior Ranger, dutifully read all of the educational signage, and collected medallions for my walking stick at every park I could. As I mentioned earlier, we even road-tripped across the country when I was ten, visiting tons of parks along the way, including those memorable few days at the Grand Canyon.

And that love for nature that started early has stayed with me into my adult life—most of my vacations revolve around hiking, backpacking, or just being outside somewhere. I live in Raleigh, North Carolina, now

with my husband, Taylor (and our sweet and spunky cat, Suki), after years in DC, and in both city environments we have constantly sought solitude in nature at local and state parks—thankfully both cities have great nearby parks! We plan frequent trips out to the Appalachians, whether visiting a national park, national forest, or state park, and I take at least one trip annually to more distant locations. As that ten-year-old version of me who wanted to head down into the Grand Canyon would be happy to know, the bottom of a canyon has become my favorite place to be—at age twenty-nine, I finally made it into the depths of the Grand Canyon, on a three-day, fifty-five-plus-mile backpacking trip through tribal canyon lands that only deepened and solidified my love for the outdoors (and opened up a whole new world of places to explore, since I now knew I was capable of a multiday backpacking trip!). I've hiked, camped, and driven through countless National Park Service sites, as well as state and local parks and other public lands.

It seems only natural that my love of the parks would eventually bleed together with my love of art. At age five, I declared that I wanted to be an artist when I grew up. As the years went on, the often clever and punny world of advertising drew me in, and I wound up studying both subjects in college, figuring that I wouldn't be able to make much of a living with just an art degree. After years jumping between marketing and graphic design jobs but always feeling a pull toward my artistic hobbies, I decided to try to make the leap into being a professional hand-lettering artist and illustrator, and the Subpar Parks project is what helped me achieve it. Most people in creative industries will tell you that the holy grail—a project that perfectly combines some of your interests and makes you excited to jump out of bed and work on it every day—doesn't come around very often. The one-star reviews of the parks were a lightning bolt of inspiration, and I knew immediately that Subpar Parks was a holy grail project for me, perfectly combining my interests, skills, and personality. A project that combined my love of the outdoors with illustration *and* hand-lettering, plus a lot of sarcasm and ample opportunities for puns? Sold. I think my passion and excitement for the project is part of what made it such a success (and eventually led to me being able to work full-time as an artist!).

I started with the iconic Delicate Arch in Arches National Park in Utah, which one unhappy reviewer described as looking "nothing like the license plate." I gathered all of the reviews for the project before I started, and that review stuck out to me the most. While I hadn't yet been to Arches, I'd always wanted to go, and I thought it was especially funny to illustrate a negative review that compared a real-life wonder of nature unfavorably to an illustrated representation of it. Next was Joshua Tree, a

desert wilderness larger than Rhode Island, and an excellent place to hike for stunning views of the Coachella Valley—an activity characterized by one disappointed reviewer as just "walking around in the desert." Then came that "very, very large hole" that is so near and dear to me. A part of me worried that people wouldn't understand what I was doing, but I couldn't have been more wrong. The laughter was immediate, and I quickly started posting twice per week instead of my planned once-a-week timeline because the community that was forming was so engaged and brought me so much joy. The project resonated with hard-core adventurers and casual park visitors alike, along with park rangers and even those who work in other industries where they're often on the receiving end of criticism. (I've heard from many servers and retail clerks that Subpar Parks has helped them laugh off the feedback from disgruntled customers they deal with all day.)

Subpar Parks grew beyond its original snarky premise into a wonderful community of park lovers who eagerly comment and send messages and photos with their own experiences in these incredible places. At a time when many of us couldn't travel due to COVID-19, the project became a space for us (including the occasional park social media account!) to come together in our appreciation for the natural, cultural, and historical wonders we couldn't go see. The wonky lens through which nature's critics see the parks somehow made it even clearer how incredible these places actually are, and my favorite part of the project by far became the photos and stories people would send of their time in the parks.

In this book, you'll find a few things: basic facts and history about each park, anecdotes from myself and some wonderful park rangers who've shared with me, tips for making the most of your visit, and many new illustrations and in-progress sketches showing my illustration process. I get a lot of questions about how each piece comes together, and I've broken it down here—how each one begins with a rough sketch based on my own photos of the parks I've been to or referencing multiple photos of iconic scenes, plus the hand-lettering of the review, of course! Then I add in blocks of color and only the shadows and highlights necessary to capture the essence of the view—the illustration style for this project is intentionally minimalist, simple, and slightly cartoony. After that, I add rough texture to everything to give it a somewhat retro feel and provide additional shading and depth. Each piece takes about five to six hours to complete from sketch to final park snark!

And about that snark—you'll see as you read, I noticed a few patterns that emerged among the reviews that feel worth noting.

THAT'S A FEATURE, NOT A BUG

Sometimes, the visitor seems to be complaining about exactly what the park is known for, what you should expect, or what most people go there hoping to do or see! Bears roaming around? No thank you. Deserts stretching for miles and miles? Hard pass. How dare this park deliver exactly as advertised! They also often don't seem to realize how lucky they are to have experienced what they're complaining about—many folks who have visited Kenai Fjords, for example, told me they'd have been over the moon to see "only" one humpback while they were there.

WILDLIFE IS WILD (AND WEATHER IS . . . WEATHER)

So many reviews refer to the unpredictability of wildlife or the weather, from not seeing whales or bears in Alaska, to a lack of bison in the Midwest and Intermountain parks, to being rained on or having views obstructed by fog. Part of the beauty of these parks is that they provide a bit of mostly untouched wilderness for wildlife to thrive, and the massive size of many parks means seeing wildlife is not guaranteed, especially if you only drive up to overlooks for a brief moment and leave. As for the weather, check the forecast and take the rest up with Mother Nature. (Good luck. She doesn't have a complaint box.)

UNPLUGGING IS KIND OF THE POINT

I can't even tell you how many reviews there are about the lack of Wi-Fi or cell phone service in parks. Many parks have even resorted to putting this in their FAQs to try to make sure people know up front that they likely won't be able to immediately 'gram their visit before they've even left the park. Take it as a sign, and put your phone on airplane mode. You might find a more worthwhile connection, both with nature and the people you're exploring with.

TECHNICALLY TRUE/ UNDERSTATEMENT OF THE CENTURY

My personal favorite reviews are the ones where the reviewer takes all of the awesome beauty around them and summarizes it in the least interesting and most reductive way possible: A very, very large hole. "Basically" a desert with some dead trees. "Just" a big mountain of sand. I mean, yes, I guess you're not wrong, but most people are wowed by these things you are dismissing as "just." If you're feeling this way, maybe you're not giving yourself enough time to really take in what's around you.

Even though this book is about hilarious bad reviews, the irony of it all is that I'm still sensitive to criticism myself. Every time I put a new piece out there, I've felt a huge amount of fear about sharing it. What if my illustration sucks, or people don't get what I'm trying to do? Am I even "outdoorsy" enough to do this? The anonymity of the internet often gives people permission to be cruel and forget the human being on the other side of the screen, and criticism can be swift, mean-spirited, and pile on quickly. Nobody wants to be on the receiving end of it.

But every time, I've received the reaction I most hoped to get—appreciation, the virtual version of laughter, and a community that gets exactly what I'm trying to share (and people who gently correct me if I've misstated a fact!). I think Subpar Parks resonates with so many people because it cuts through negativity so sharply. Laughing at a critique of nature comes easily. Who has the audacity to criticize the height of a mountain or the colors of a canyon? But I hope it can also teach us to laugh at our own critics (including the one in our own head), recognize the imperfect humans we all are, and let that shit go. As I constantly try to remind myself when I'm spiraling about negative feedback, if the best the planet has to offer can get a one-star review, you don't have a chance of pleasing everyone. And as many of the one-star reviews that actively contradict one another prove (one person complaining about too many bears followed by someone complaining that there aren't enough, for example!), there will always be someone ready to complain, no matter what you do. Don't take it personally.

The next time you're staring down the face of crippling criticism or fear of not being good enough, I hope you'll remember the message of Subpar Parks. As our "conservation president" Teddy Roosevelt once said: "It is not the critic who counts; not the man who points out how the strong man stumbles, or where the doer of deeds could have done them better."

A BRIEF HISTORY OF THE NATIONAL PARKS AND HOW THIS BOOK IS ORGANIZED

The National Park Service was first established on August 25, 1916, under the Department of the Interior, to manage federal lands that were already being preserved. (You'll notice that many parks were preserved well before the NPS officially existed!) Initially overseeing just thirty-five sites, the park service has grown over the last hundred-plus years to include more than 420 parks, monuments, recreation areas, lakeshores, seashores, memorials, and more. They protect over eighty-four million acres of land across all fifty states (plus Washington, DC, and American Samoa, Guam, Puerto Rico, Saipan, and the Virgin Islands), and the areas they oversee range in size from 0.02 acres in Pennsylvania to 13.2 million acres in Alaska. The park service is split into geographic regions—Alaska, Pacific West, Intermountain, Midwest, Northeast, National Capital, and Southeast—and this book is organized in the same way.

The variety of designations for parks often confuses people, and throughout this book you'll find several different types of parks. The two most common you'll see are national parks and national monuments, the key difference being that a national park is formed by an act of Congress, and a national monument is formed by the president under the Antiquities Act. Of course, parks can and do change designations! Many national parks started out as national monuments, and our newest national park as of 2020, New River Gorge, was originally a national river. The year of establishment I call attention to in the book is the year the area received national park designation, but many were protected long before that year. While all of the sites in this book are managed by the National Park Service, many national monuments are overseen by the Bureau of Land Management, the US Forest Service, the US Fish and Wildlife Service, or indigenous tribes, or are even jointly managed by a combination of these groups.

While the sixty-three national parks tend to get the most attention, that doesn't mean

the other designations are any less special. (Remember, Congress assigns national park status, so sometimes a park is elevated to national park status from another designation simply as a bid to increase tourism in a state!) Most of the park designations simply signify why an area was protected, or what kind of restrictions on activities and development are in place. To explain a few: national memorials commemorate historic persons or events, national historic sites and historical parks preserve areas of historical significance, national military parks and national battlefields honor important sites in our military history, and national recreation areas are typically land near large reservoirs that offer both land- and water-based activities. National rivers, lakeshores, and seashores, probably obviously at this point, protect important natural water sources and their surrounding lands. National preserves are like national parks (and many parks combine both a park and a preserve in different areas) but typically allow activities like fishing, hunting, mining, and oil or gas extraction that national parks do not. I could go into it in a lot more detail, but hopefully you get the gist! If you want to learn more, there are good articles explaining all of the designations on the NPS and Department of Interior websites. To most visitors, the designation won't make a ton of difference in your experience in the park, but it can give you a bit of a heads-up as far as what kinds of things you can expect to see or learn there.

As I've mentioned, many parks were preserved in some capacity before the National Park Service existed, but the significance of all of these lands goes back much, much further than that. Throughout this book, I've tried to include information about the indigenous history and relationships with these lands where I can. This is far from comprehensive and I'm no expert, but I assure you: basically every park in the United States has both historic and present-day significance to at least one Native American tribal nation. I can't cover every nation and every park's full history, as that would and should be its own book, and I encourage you to research every park you visit. It's not always presented front and center at the parks, and often the United States' role in this history is violent and destructive. It's easy to find information online about the historic and modern-day tribes in each region. At the back of this book, I've included some resources that may help you learn, but when in doubt, simply google "indigenous tribes/history of [where you're going]." These lands hold deep, sacred meaning for many nations, and I try to be respectful of this in every park I visit (I also find that learning about Native culture, history, and their original place names often helps me appreciate and connect with the park even more).

★ SUBPAR PARKS

GATES OF
THE ARCTIC

KOBUK
VALLEY

Alaska

DENALI

WRANGELL-ST. ELIAS

LAKE
CLARK

KENAI
FJORDS

KATMAI

GLACIER
BAY

ALASKA

The Alaska Region of the National Park Service manages parks in . . . you guessed it, Alaska! Preserving millions of acres of wilderness and human history going back more than fourteen thousand years, the Alaska Region is full of both natural and cultural wonders. Alaska has the nation's largest glacial system, incredible opportunities for seeing wildlife in their unspoiled natural habitats, North America's tallest peak, and millions of acres of untouched wilderness, making it the perfect place to travel long distances and be . . . completely underwhelmed.

BARREN
WASTELAND OF
TUNDRA

DENALI
NATIONAL PARK

ALASKA ★ ESTABLISHED 1980

Oh, right, sure, Denali is absolutely barren. If by "barren," you mean it's a six-million-acre Alaskan wilderness full of spruce forests, two thousand species of plants, grizzly bears, wolves, moose, caribou . . . not to mention the highest peak in North America.

Towering above the rest of the landscape at 20,310 feet and often visible from two hundred miles away, Denali itself is a massive sight to behold to most people. (One ranger shared with me that she thinks some visitors who say "That's it?" simply can't comprehend how far away Denali is from them for how big it looks, and thus think it actually looks small!) Denali was created to protect the wildlife that call it home—five mammals are caribou, moose, Dall sheep, wolves, and grizzly bears. Between the wildlife and the epic scenery, it's hardly what I'd call barren.

FUN FACT:
Denali is the only national park to employ sled dogs! Each year the park adopts or breeds a litter of sled dogs, and they work side-by-side with rangers to protect the wilderness and ensure a great visitor experience.

WHAT'S IN A NAME?

For thousands of years, Alaska Natives have lived on the land around Denali and used its resources for food, shelter, clothing, and trade. The name *Denali* means "the tall one" or "mountain-big" in Athabaskan. In 1896, a gold prospector renamed the mountain Mount McKinley after US President William McKinley. McKinley never visited the mountain, or Alaska, and in 1975, Alaska changed the name back to Denali. The name was fully restored federally in 2015 by President Obama.

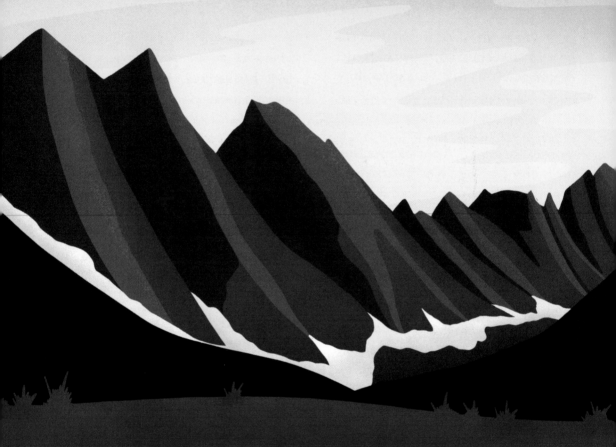

GATES OF THE ARCTIC

NATIONAL PARK

ALASKA ★ ESTABLISHED 1980

It was a good effort, Mother Nature, but the scale here feels just a bit off!

Like many Alaska parks, Gates of the Arctic is incredibly remote—this vast landscape does not contain any roads or trails, or any established campsites. The park has no set routes in place, and visitors can wander across 8.4 million acres of natural beauty virtually unchanged by man.

Here you can explore jagged peaks that rise to more than seven thousand feet above sea level (they really ought to be at least double that height, though) as well as Arctic valleys, wild rivers, and many lakes. Be ready for a tough trek, as hiking six miles in one day is considered a lot of progress at Gates of the Arctic given the thick brush and lack of established trails.

As the saying goes, where the road ends, the real Alaska begins—and Gates of the Arctic is no different. To get to this wilderness requires a ride on a bush plane, which makes it even more baffling to travel so far and be disappointed by the height of the mountains.

> "A national park is not a playground. It's a sanctuary for nature and for humans who will accept nature on nature's own terms."
>
> —MICHAEL FROME

RANGER TIP: THERE'S NO ACTUAL GATE (AND ALSO NO MAJOR HOTELS)

Apparently, many visitors expect to find an actual physical gate welcoming them to the Arctic, but you won't find one here. You also won't find many hotels! One ranger spoke with a prospective visitor who was planning on driving from New York to the park and back . . . in a single weekend. He was looking for the closest Hilton hotel, which you might find in Anchorage—600 miles away!

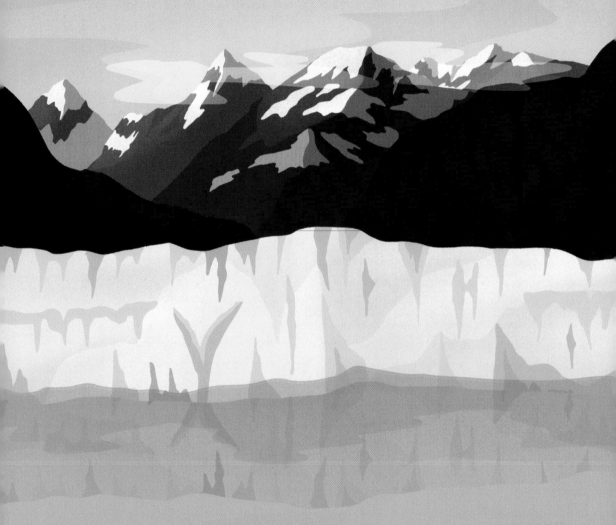

GLACIER BAY
NATIONAL PARK

ALASKA ★ ESTABLISHED 1980

Maybe this was the same reviewer who visited Denali, because if over one thousand glaciers (several of which make the boat you can tour them on look like a toy), plus whales, sea lions, sea otters, and puffins don't make Glacier Bay great, I really don't know what will!

Glacier Bay is another massive Alaskan park, covering 3.3 million acres of mountains, glaciers, rainforest, coastlines, and fjords. Originally protected as a national monument in 1925, it was expanded and given national park status in 1980. From sea to summit, Glacier Bay is full of stunning Alaskan views if you're open to at least some exploring to see just how great it actually is.

Glacier Bay is the ancestral homeland of the Huna Tlingit people. They originally called the area S'e Shuyee, meaning "edge of the glacial silt," and were forced to abandon their original settlements in the 1700s due to an advancing glacier. They returned when the glacier retreated, and called the area Sit' Eeti Gheeyi, meaning "the bay in place of the glacier." But then the bay was made into a national park and they were forbidden from fully returning. In 2016, Xunaa Shuká Hít, the Huna Tribal house, was completed inside the park, memorializing the four Tlingit clans who lived in the region, and providing opportunities for visitors to learn about Tlingit culture. Today, Tlingit guides work with the park to provide educational programs to visitors, through lectures, storytelling, singing, and displays of traditional art, tools, and craftsmanship.

The best way for day visitors to experience the full sea-to-summit glory of Glacier Bay is through a boat tour. Plan ahead because they do fill up! The tour takes visitors on an eight-hour journey to see the epic tidewater glaciers and snowcapped mountains that make up the iconic landscape. Plus, you have the potential to see whales, Steller sea lions, puffins, coastal bears, seals, and eagles! Glacier Bay houses the world's largest concentration of actively calving tidewater glaciers, so you might even see (and hear) icebergs breaking off from the glaciers, a sound the native Tlingit people called white thunder. Be sure to bring binoculars and rain gear, and dress in layers.

KATMAI
NATIONAL PARK

ALASKA ★ ESTABLISHED 1980

I guess you could say visiting Katmai National Park was pretty un-*bear*-able to this person, eh? Pun intended, and I'm not sorry.

Katmai was first established as a national monument in 1918 to protect the Valley of Ten Thousand Smokes, which had been devastated by the Novarupta eruption in 1912 (thirty times larger than Mount St. Helens's famous 1980 eruption!). Expanded in 1980 as Katmai National Park and Preserve, today it protects nine thousand years of human history and important habitat for salmon and thousands of brown bears.

Bears are all over Katmai, and they're definitely the park's claim to fame. Few places on earth have as many bears as Katmai or offer comparable bear-viewing opportunities. But as always, wildlife is wild and can be tough to predict—these bears do not appear on command. With 5,700 square miles to roam, the bears have plenty of places to hide from ogling visitors. Katmai's most popular destination is Brooks Camp, due to its combination of bear watching, fishing, gorgeous scenery, and access to facilities. In peak bear-watching times, this is the place to watch bears in the Brooks River feasting on salmon.

Bears are such a big deal in Katmai that every fall, the park celebrates by hosting an online competition called Fat Bear Week. As the bears near the end of their feeding season before hibernation, the park puts out a bracket online and shares photos of the contenders, and you can vote for which bear you think is the fattest based on their before and after photos (which are truly mind-blowing transformations over just a few months—brown bears are often twice as heavy before hibernation as they will be when they emerge in the spring!). The bear's actual weight isn't the deciding factor in victory—it's a single-elimination tournament based on votes, and the bears' weights are estimated later. Some of the past winners are on the next page—2020's winner, Bear 747, is estimated to weigh over 1,400 pounds!

Fat Bear Week Winners

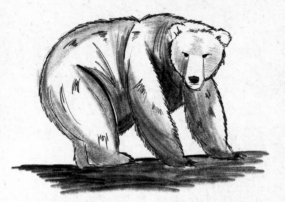

2020: 747, aka "Earl of Avoirdupois"

2019: 435, aka "Holly"

2018: 409, aka "Beadnose"

If you'd like to partake in other activities besides bear watching, Katmai has plenty else to do! There are few established trails in the park, as with many Alaskan parks, but near Brooks Camp are several trails leading to incredible scenery. You can also fish and boat in the park's pristine rivers, streams, and lakes, or explore the many cultural sites. Before the devastating volcano eruption that led to Katmai's eventual protection, the area was home to Native Alaskan Alutiiq people, who were forced to leave because of the eruption and whose descendants still live in nearby areas of southwest Alaska.

Even if you can't make it out to Katmai, you can still get in on the bear-watching fun! Katmai National Park and Explore.org have also created a livestream feed of the falls, where you can see the bears in real time on the cameras, typically from late June until early October. (In the off-season, they show highlights from the previous year, so it's year-round fun even when the bears are off hibernating!)

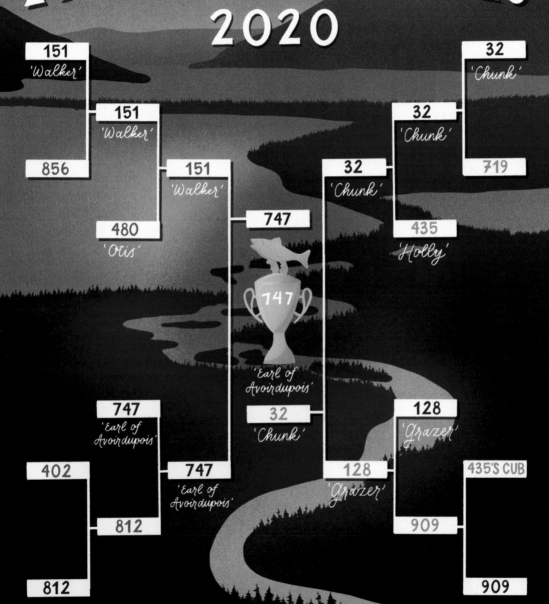

KENAI FJORDS

NATIONAL PARK

ALASKA ★ ESTABLISHED 1980

I can't imagine why the National Park Service doesn't corral wild thirty-ton humpback whales so we can gawk at them all day. It's not like there's anything else interesting to see here.

When you visit a park like Kenai Fjords, you are in wild, untamed land—not a zoo or animal park, where animals are confined to a restricted area. They are completely wild and free to roam as they naturally do, seeing as they actually *are* in their natural habitat! As with all wildlife experiences, whether you see them is a combination of the right conditions and a lot of luck, and there are, of course, no guarantees.

But even if you don't see a whale, the rocky coastline of the Kenai Peninsula itself is always a sight to behold. Nearly forty glaciers flow from the Harding Icefield, and the coastline has eroded into otherworldly spires, cliffs, and coves. And the unique geography makes it a prime spot to see all kinds of other wildlife. About twenty species of seabirds nest along the coast, and harbor seals, sea lions, sea otters, moose, black bears, wolverines, and coyotes all call this park home as well.

TRUE BOAT TOUR STORY: "HOW DO YOU FIND THE ISLANDS?"

"Once someone asked one of my crew members how we find the islands we visit each tour. She explained how we use the boat's navigation system, and they responded with, 'Well don't the islands move around each day? How do you know where to find them?' They had no idea that islands do not float around the ocean but are actual landforms." D'oh!

KOBUK VALLEY
NATIONAL PARK

ALASKA ★ ESTABLISHED 1980

Most people would travel to a nearly two-million-acre park in Alaska *hoping* to be alone in a peaceful wilderness, but I guess that's just not some people's cup of tea.

A little research shows that you have pretty high odds of being by yourself here—Kobuk Valley is one of the least visited national parks (second only to its neighbor, Gates of the Arctic), but that's not because it's not spectacular. Kobuk Valley encourages traditional native subsistence practices, so there are no facilities or formal trails in the park. Plus, 1.8 million acres of remote backcountry offers a lot of room for solitude!

Kobuk Valley is best known for its Arctic sand dunes, formed by glaciers thousands of years ago. The Great Kobuk Sand Dunes are the largest active sand dunes in the Arctic and cover thirty square miles, sometimes reaching as high as one hundred feet. More than half a million caribou migrate through the area each year, leaving their tracks crisscrossing the dunes.

Summer is the best time to visit, with boat-ing, camping, hiking, backpacking, wildlife-watching, and fishing opportunities galore, but this park isn't for the casual tourist. Visiting here requires a lot of planning and preparation given the lack of facilities, but for visitors with the right skills and mindset, it's the mysterious, silent, and lonely trip of a lifetime!

Kobuk Valley: Where caribou can outnumber visitors 32 to 1

Annual Visitors (2019): 15,766
Caribou: Up to 490,000
Acres: 1,750,716

LAKE CLARK
NATIONAL PARK

ALASKA ★ ESTABLISHED 1980

I think it's clear that this reviewer and I simply have different definitions of "nothing." In a place as beautiful as Lake Clark, even doing nothing would be quite something to me!

Lake Clark National Park is one of the most remote national parks, accessible only by boat or floatplane. The park protects rainforests along the coastline, alpine tundra, glaciers, glacial lakes, major salmon-bearing rivers, and two active volcanoes!

It's hard to imagine traveling all that way and wanting to do anything more than stare at this beautiful turquoise lake, but I guess this person wasn't aware of the fishing, kayaking, and hiking opportunities. If you're going to go through the effort it takes to visit, probably do some research ahead of time so you can make the most of it!

Lake Clark National Park is a stunning and mostly untouched wilderness—looking at photos for inspiration for my illustration, I was completely mesmerized by the scenery. Steaming volcanoes and rugged mountains reflect crisply in the gorgeous turquoise waters, which are full of salmon, and on the shores you can often spot bears, wolves, and bald eagles. The area is so rich with resources that local people and cultures still rely on the land and water. The native Dena'ina people have been in the Lake Clark region for thousands of years, and around 1,400 Dena'ina live in the area today. They believe that everything in Qizhjeh Vena, their name for Lake Clark, has a spirit and should be treated with respect.

BLACK BEARS

ROAMING ABOUT

WRANGELL-ST. ELIAS

NATIONAL PARK

ALASKA ★ ESTABLISHED 1980

While this person mentioned bears not once but *twice* in their one-star review, let us all take a moment to appreciate the irony that one of the only other negative reviews of this park is that there isn't *enough* wildlife. Alaska is proof that you simply can't please everybody.

Wrangell–St. Elias is the largest US national park—it's basically six Yellowstones (let that sink in—six! Yellowstones!), spanning over thirteen million acres of wilderness. Here you'll find mountains that dominate the horizon, tons of glaciers, and, like in much of Alaska's protected wilderness, few roads. With nine of the sixteen highest peaks in the United States and the largest glacial system in the US, including the famous Hubbard Glacier, Wrangell–St. Elias proves that everything is actually bigger in Alaska, not Texas.

And of course the massive wilderness of Wrangell–St. Elias is home to tons of wildlife. Bison, beavers, and, yes, bears abound, along with fifty-one other species of mammals, free to roam about through this untouched wilderness.

THE BIGGEST OF THEM ALL (AND IT'S NOT EVEN CLOSE)

At 13.2 million acres, Wrangell–St. Elias National Park is almost the size of West Virginia, and is 1.5 times the size of the next largest park (Gates of the Arctic clocks in at 8.47 million acres). To compare it to more commonly visited parks, if you combined the ten most visited national parks, you'd still only have just over half of Wrangell–St. Elias! (You can check my math for yourself: Great Smoky Mountains [522,427 acres], Grand Canyon [1.2 million acres], Rocky Mountain [265,769 acres], Zion [148,016 acres], Yellowstone [2.2 million acres], Yosemite [759,620 acres], Acadia [47,000 acres], Grand Teton [310,000 acres], Olympic [1 million acres], and Glacier [1 million acres].) The kicker? Those parks see a combined total of over 49 million visitors a year, while only around 75,000 folks brave the wilderness in Wrangell–St. Elias every year.

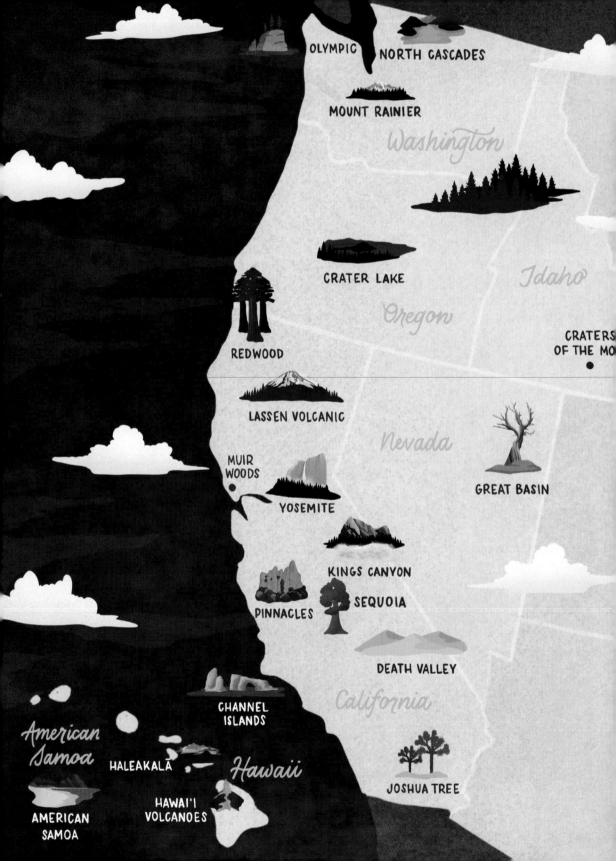

OLYMPIC NORTH CASCADES

MOUNT RAINIER

Washington

CRATER LAKE

Idaho

Oregon

CRATERS
OF THE MO

REDWOOD

LASSEN VOLCANIC

Nevada

MUIR
WOODS

GREAT BASIN

YOSEMITE

KINGS CANYON

PINNACLES

SEQUOIA

DEATH VALLEY

California

CHANNEL
ISLANDS

*American
Samoa*

HALEAKALĀ

Hawaii

JOSHUA TREE

AMERICAN
SAMOA

HAWAI'I
VOLCANOES

PACIFIC WEST

The Pacific West Region of the NPS covers parks in Washington, Oregon, Idaho, Nevada, California, Hawaii, and the territories of Guam, American Samoa, and the Northern Mariana Islands. From stunning coastal parks to some of the highest and lowest points in the United States, this region protects a diverse range of places, including many sites of historic significance and some of the oldest national parks in the country. With the variety of geography, climate, and activities in the parks in this region, you'd think everyone would be able to find something they enjoy, but the Pacific West is proof that there's just no pleasing some folks.

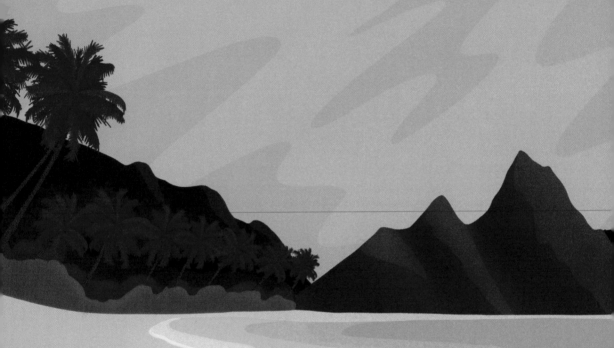

AMERICAN SAMOA

Ah, yes, the *hassle* of flying to a collection of lush, remote tropical islands with pristine beaches where the weather is 70 to 80 degrees pretty much year-round. How inconvenient!

The National Park of American Samoa is the only US national park located in the Southern Hemisphere. American Samoa consists of ten volcanic islands (five of which are inhabited) in the South Pacific. The park spans three of the islands—Tutuila, Ofu, and Tau. The land is leased from seven villages, protecting over nine thousand acres of land and ocean. American Samoa offers rugged cliffs, amazing coastal views, stunning beaches, coral reefs, and tropical rainforests, plus plenty of tropical birds and fish!

In addition to preserving the natural wonders of the area, the park educates visitors about Samoan culture, the oldest culture in all of Polynesia. The first people to the Samoan islands came from Southeast Asia over three thousand years ago. The culture that developed here, one of deep respect for the islands and their resources (*Samoa* means "sacred earth"), came to be known as Fa'a Sāmoa, or "the Samoan way."

If immersing yourself in the customs, beliefs, and traditions of the three-thousand-year-old Samoan culture while exploring tropical rainforest and coral reefs sounds like your jam, I don't think you'll be disappointed. Of course, if that's not your thing, maybe figure that out before you take a ten-plus-hour flight from the US mainland to get there?

"Those of you who have had the opportunity to visit Hawaii or any of the Polynesian islands know that it's a very special thing. It's an intangible, and when you get off the plane and have your feet on the ground there, it energetically takes you to a different place."

—DWAYNE JOHNSON

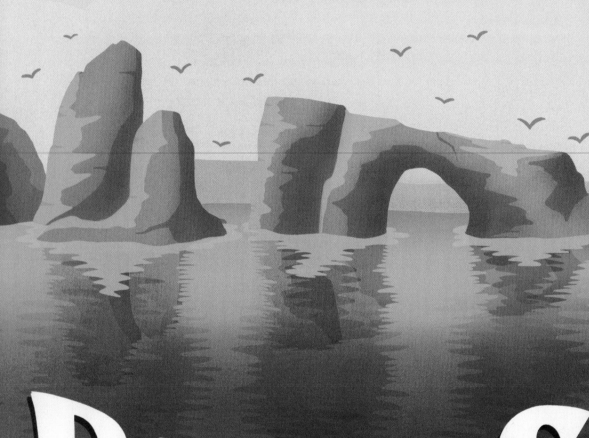

TOO MANY

BIRDS

CHANNEL ISLANDS
NATIONAL PARK

CALIFORNIA ★ ESTABLISHED 1980

Birds? Flying around outside? No one told me this would be a thing.

Just off the coast of Southern California, Channel Islands National Park was established to protect areas of natural and cultural significance both on the islands and within the waters of the area. The Channel Islands are vital habitat for shorebirds and seabirds, offering a winter resting area for shorebirds and providing important nesting and feeding grounds for 99 percent of seabirds in Southern California. So yeah, that's a LOT of birds! Beyond the birds, the islands also have plants and animals found nowhere else on earth. The islands were created by tectonic forces that caused them to rise up out of the ocean, so they've always been separate from the mainland, creating this unique habitat.

RANGER TIP: DIFFERENT ISLANDS OFFER DIFFERENT EXPERIENCES

Channel Islands is a collection of five islands (San Miguel, Santa Rosa, Santa Cruz, Anacapa, and Santa Barbara), each one offering different experiences. For fewer crowds, head out to Santa Rosa Island. It's a bit more expensive to get out to it, and you'll spend less time out there on a single day trip than on islands closer to shore, but you get to see the extremely rare Santa Rosa Island Torrey pine. You're not as likely to see the legendary island fox, so if that's the main draw for you, head to Santa Cruz! The Scorpion Canyon Loop goes through the campgrounds where the foxes can often be found.

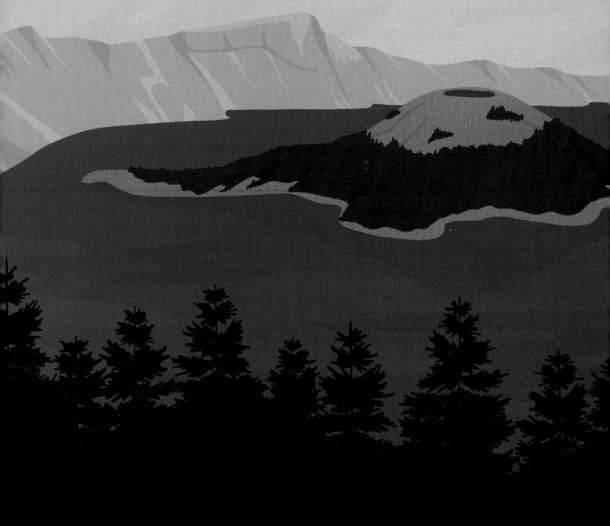

CRATER LAKE

NATIONAL PARK

OREGON ★ ESTABLISHED 1902

This just goes to show you that with the right mind-set, even the deepest lake in the US, which is literally in a COLLAPSED VOLCANO, can be boring.

At 1,943 feet deep, Crater Lake is the deepest lake in America. Famous for its deep blue color, the lake's water comes from snow or rain—there are no other water sources! This means no sediment or mineral deposits are carried into the lake, which allows for its rich color. It's one of the cleanest and clearest lakes in the world. And it's not just a sight to behold, despite what this reviewer thinks. Visitors can swim at designated areas, but beware: the water is typically pretty cold, rarely getting above 60 degrees Fahrenheit, much like the North Atlantic Coast!

Even if you do just want to have a look, there are plenty of opportunities to do so—the drive around Rim Drive features more than thirty scenic pullouts. At Pinnacles Overlook, you can see volcanic ash frozen into hundred-foot-tall rock formations, and Vidae Falls includes a beautiful waterfall and lots of plant life.

Don't leave without stopping by Pumice Castle Overlook, where an orange layer of pumice has eroded into the shape of a castle!

YES, YOU CAN VISIT WIZARD ISLAND!

After the eruption and collapse of Mount Mazama, which formed the caldera that's now Crater Lake, a buildup of hot cinder was ejected from the caldera floor, forming the 763-foot-tall cinder cone known as Wizard Island (so named because it kind of looks like a wizard's hat). In the summer, there are boat tours that will take you out to the island.

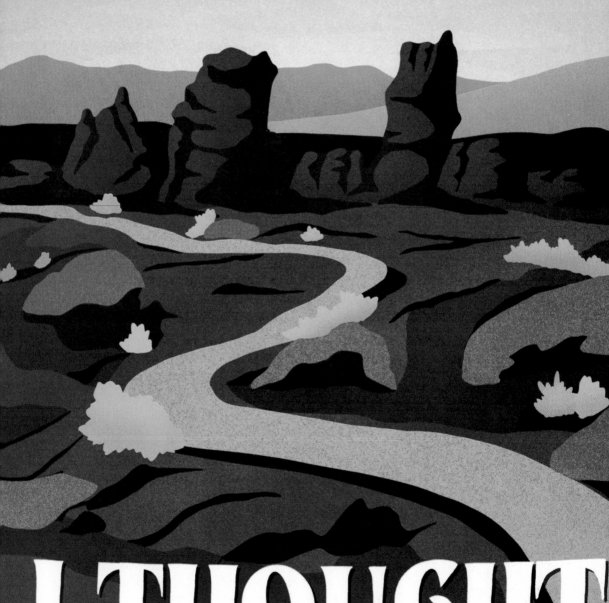

CRATERS OF THE MOON

NATIONAL MONUMENT

IDAHO ★ ESTABLISHED 1924

Maybe this visitor thought they were actually going to the moon?

Craters of the Moon National Monument spans over 750,000 acres (bigger than Rhode Island!) in Idaho, protecting lava flows, craters, and other volcanic formations. The landscape is weird and wonderful, full of unusual terrain, so it's no wonder its name references something not of this world. The barren-looking landscape might give you the impression that the park is relatively lifeless, but explore for a while and you'll likely find many of the plants and animals that call the area home.

Marmots, foxes, mule deer, and a wide variety of birds, reptiles, and amphibians abound, but most desert animals are nocturnal. In addition to juniper trees, sage-brush, and other native plants, wildflowers put on a spectacular display each spring. You might notice that they're very evenly spaced; but they're not planted by anyone—they naturally space themselves, as lack of water prevents them from growing too closely together and crowding resources!

> ## "Nature is just enough; but men and women must comprehend and accept her suggestions."
> —ANTOINETTE BROWN BLACKWELL

HOW DID THE MONUMENT GET ITS NAME?

Local legends talked about how the lava-flow landscape resembled the surface of the moon, even referring to the area as the Valley of the Moon. Robert Limbert, the first man to thoroughly explore and advocate for the area, used the name *Craters of the Moon* in an article, and the name became official with the establishment of the monument in 1924.

-29-

UGLIEST

PLACE

I'VE EVER SEEN

DEATH VALLEY

NATIONAL PARK

▶ CALIFORNIA AND NEVADA ★ ESTABLISHED 1994 ◀

Head to Death Valley National Park and witness the ugliest place this one guy on Yelp has ever seen!

Death Valley was given its grim moniker by a group of pioneers who got lost there in 1849. Only one member of the group died, but because of the conditions, none of them thought they'd make it out alive. They were eventually rescued, and as they climbed out of the valley, one of the men supposedly looked back and said, "Goodbye, Death Valley." The name stuck, and the hottest, driest, and lowest national park in the United States is now known as Death Valley—but why we have permanently named this amazing place after one worst-case scenario is beyond me. Add it to my ever-growing list of parks that I think need to be renamed!

Before it was given this foreboding name, it was the home to the Timbisha Shoshone, and they considered it quite the opposite of a Death Valley. They call the area Tüpippüh, meaning "homeland," and believed they were living in a magical valley of abundance, where they flourished for over a thousand years. In 2000, 7,500 acres of ancestral homeland in Death Valley was returned to the tribe, and many descendants of the original inhabitants still live there today.

Death Valley is famous for its extremes. While it's known as the hottest place on earth and contains the lowest point in North America, it also has mountains. Telescope Peak, at over 11,000 feet above sea level, is snowcapped for much of the year. You also might not expect wildflowers in a place called Death Valley, but from February through April the park is often covered in brilliant purple, pink, yellow, and white flowers—some years it's a small showing, but about once a decade, the park experiences a super bloom.

Zabriskie Point is one of the most famous views in the park, with corrugated golden badlands stretching out in front of you and mountains in the distance. With its panoramic views and otherworldly colors, it's a great spot to catch a sunrise or sunset!

WHO MOVED MY ROCK?

Racetrack Playa is home to one of Death Valley's most famous mysteries, known as the "sailing stones." Hundreds of rocks are scattered across the bottom of the dry lake bed, but they mysteriously move and leave trails. Some rocks, which weigh up to seven hundred pounds, have somehow traveled over 1,500 feet! In 2014, researchers finally figured out what was going on. (If you'd prefer to continue thinking they were moved by aliens, feel free to skip the rest of this paragraph!) Sometimes, during periods of heavy rain, the lake bed collects water that freezes into a thin layer at night and then breaks into panels of ice during the day. The wind slides the rocks across the slippery surface, leaving trails in the soft mud underneath.

LITTLE MORE THAN A
CAVE AND A

MOUNTAIN

GREAT BASIN
NATIONAL PARK

NEVADA ★ ESTABLISHED 1986

What good is a national park if it doesn't have at least a cave, a mountain, a desert, a tundra, AND a jungle all in one?

From rugged mountain peaks to huge underground caves, this 77,100-acre park in Nevada appears barren and desolate at a glance, but it's home to a diverse range of plant and animal life, plus a wide variety of activities for visitors! There's a beautiful scenic drive along Wheeler Peak, cave tours, over sixty miles of hiking trails, and places to fish and camp.

It's also a great place for stargazing. The low humidity and minimal light pollution in Great Basin National Park gives it some of the darkest night skies in the United States, making it an amazing place for amateur astrologers! The annual Great Basin Astronomy Festival includes stargazing education, astrophotography workshops, and telescope observing each night. Brb, adding this to my bucket list!

> "In nature, nothing is perfect and everything is perfect. Trees can be contorted, bent in weird ways, and they're still beautiful."
>
> —ALICE WALKER

DON'T GET IT TWISTED

Some of the oldest trees on earth live in Great Basin National Park. The iconic bristlecone pine grows near the tree line, where it can live for four thousand years or more under extremely harsh conditions. The bristlecone pine's twisted shape is due to the protective bark slowly turning due to high winds, and it has a special "sectored architecture" that allows the tree to live on if the roots in one section die. The oldest known tree in the park was named Prometheus, but it was cut down in 1964 by a graduate student for research purposes (*whomp whomp*) and was later estimated to be 4,900 years old. The oldest known currently living bristlecone pine was found in 2012. Named Methuselah and currently a ripe old age of 5,065, the tree lives outside of the park, in a secret location in California, where it's safe from grad students and their saws.

HALEAKALĀ

NATIONAL PARK

HAWAII ★ ESTABLISHED 1976

Another day, another sunrise on top of a volcano ten thousand feet up. Meh.

Haleakalā National Park is probably best known for its sunrise views, which are so average they require a parking reservation at least a week in advance. Mark Twain once saw a sunrise here and famously called it "the most sublime spectacle I have ever witnessed," but I guess this person had a slightly less inspiring visit. If you do plan to head to the park for the sunrise, be sure to factor in that the drive from the entrance to the summit takes about a half hour. (And be on top of getting a reservation, as only fifty vehicles are permitted to access the sunrise-viewing areas each day!)

The name is Hawaiian for "house of the sun," and according to legend, the demigod Maui, namesake for the island the park calls home, climbed to the top of Haleakalā and lassoed the sun to lengthen the day (you're welcome). It's a good thing Maui made the day longer, because there's a lot to see in this park even after you've watched the sunrise! Spanning more than 30,000 acres with 30 miles of hiking trails, the park contains an incredibly diverse set of landscapes, from the red desert-like summit to lush waterfalls and forests along the coast below.

In the Summit District, you'll find the namesake volcano, one of two volcanoes that make up the island of Maui. The summit of Haleakalā caps out at over ten thousand feet, so bring layers! Temperatures at the summit are generally at least twenty degrees colder than at sea level, so it's often below freezing up there.

I visited as a kid, and pretty much all I remember is being really cold (but that's par for the course for me personally). Keep in mind that in addition to temperature concerns, the trails around the summit are probably going to feel more strenuous than they may seem, due to the high elevation and lower concentration of oxygen.

While the summit is famous for its sunrises (and its sunsets aren't bad either), don't forget about the stars! Due to the high elevation, the sky is often clearer, with minimal light pollution, providing the perfect conditions for incredible stargazing. Bring a blanket and some hot chocolate and try to spot the Milky Way.

The Kīpahulu District preserves the ecosystems of Kīpahulu Valley and ʻOheʻo Gulch (pictured on page 39) and many rare and endangered species that live in these areas, some of which can't be found anywhere else on earth. *ʻOheʻo* means "something special," and with the lush green landscapes, pristine waterfalls, and wide ocean views, it's a classic Hawaiian landscape that certainly lives up to its name. Apart from the scenery that will greet you when you arrive, you can drive here on the scenic, winding Hana Highway (also known as the Road to Hana). This famous fifty-two-mile road has plenty of incredible overlooks, which is good because you might need a break or two to calm your nerves (or maybe that was just my family's experience with my dad at the wheel).

WHERE ARE THE SEVEN SACRED POOLS?

ʻOheʻo Gulch is often referred to as the Seven Sacred Pools, but it's quite a misnomer. There are typically far more than seven pools in this area, depending on water flow, but the name originates from old guidebooks and remains how the area is known to many visitors. P.S. *All* freshwater is considered sacred in Hawaii, not just these pools!

HAWAI'I VOLCANOES
NATIONAL PARK

HAWAII ★ ESTABLISHED 1916

Listen. I know what you're thinking. "Amber, this review was definitely a joke." I assumed it was too. But after a deep dive on this reviewer's other reviews, I am convinced otherwise (but I am hoping they wanted to touch cooled lava and didn't realize *all of Hawaii* is formed from lava).

Spanning from sea level to 13,677 feet, Hawai'i Volcanoes National Park encompasses two of the world's most active volcanoes: Kīlauea (which erupted in 2021 while this was being written) and Mauna Loa. While volcanoes are the namesake attraction, the park also includes rainforest and grassland that are home to an array of rare flora and fauna—the park protects some of the most unique landscapes in the world. The wildlife found in Hawai'i Volcanoes National Park is one of a kind, including nesting sea turtles along the beaches and thousands of bird species.

Pele is the volcano deity in Hawaii. According to tradition, she is present in lava and other natural forces associated with volcanic eruptions, and as such, lava should be approached with respect instead of fear. So when you visit Kīlauea, remember to do so respectfully. In Hawaiian tradition, it is customary to ask permission from Pele to travel through her land and this sacred landscape. It's also considered highly disrespectful to poke, prod, or otherwise disrupt flowing lava (not to mention, it's incredibly dangerous!).

RANGER TIP

To get a more secluded view of the Kīlauea caldera, branch out from the traditional viewing spots like Wahinekapu and Kīlauea Overlook. There are plenty of other places for a great sunset view of the caldera—hike along the Crater Rim Trail to find some lesser-known vantage points! Just be sure to bring a flashlight or headlamp to find your way in the dark afterward.

THE ONLY THING TO DO HERE IS
WALK AROUND
THE DESERT

JOSHUA TREE

NATIONAL PARK

CALIFORNIA ★ ESTABLISHED 1994

All there is to do in Joshua Tree is explore a desert wilderness larger than Rhode Island, full of interesting plants, animals, and geology. YAWN.

Joshua Tree's namesake *Yucca brevifolia* trees have become a pretty iconic symbol of the desert. According to legend, Mormon pioneers thought the limbs of the trees looked like the outstretched arms of Joshua leading them to the promised land, which is where the trees got the name they're most commonly called.

Walking around the desert to look at the namesake trees is far from the only thing to do in Joshua Tree, though. There are dozens of trails open to hiking, biking, and horseback riding, and the rocky terrain has made it a major destination for climbing, bouldering, and highlining (basically slacklining but much higher off the ground). In the spring, wildflowers abound, and at night, the crystal-clear and dark night sky make the park a perfect spot for stargazing. Plus, Joshua Tree actually contains parts of two different deserts, the Mojave and the Colorado. The altitude and precipitation amounts in the two deserts are very different, which creates a variety of landscapes and vegetation within the park for you to explore. The iconic Joshua trees are only found in the Mojave portions of the park, as they can't survive in the hotter, drier Colorado Desert area. So at a minimum, there are actually two deserts for you to walk around!

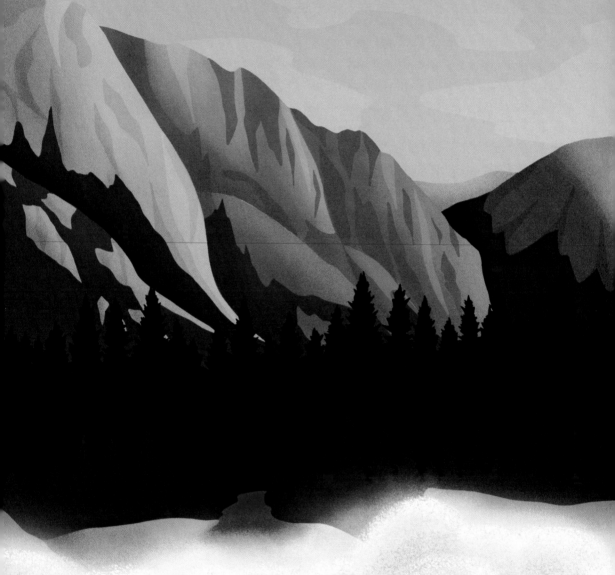

KINGS CANYON
NATIONAL PARK

CALIFORNIA ★ ESTABLISHED 1940

I think the stunning views of Mist Falls and Paradise Valley speak for themselves, but let's go ahead and get into just how scenic Kings Canyon National Park is.

Kings Canyon is the deepest canyon in the United States, reaching a depth of over a mile and a half. Sheer granite cliffs line the glacially formed canyon, and the wild Kings River meanders through it, filling the area with lush greenery. The canyon opens up to deep valleys with skyscraping trees and stunning views, making this rival to Yosemite definitely one for the bucket list—although apparently this kind of scenery isn't everyone's cup of tea.

If wide-open scenery and towering canyons aren't for you, you might take a walk through General Grant Grove, where you'll be surrounded by massive sequoia trees. Although Kings Canyon's neighboring (and jointly managed) park, Sequoia, boasts even larger trees—one park can't have it all, I suppose—Kings Canyon is home to the famous General Grant, often referred to as the Nation's Christmas Tree. It's 267 feet tall and 107 feet around at the widest point, and every December a Christmas service is held at the tree. (The tallest tree in Sequoia, and the largest in the world by volume, the General Sherman, is ever so slightly taller, at 275 feet.) Between Kings Canyon and Sequoia, you'll find about a third of all naturally occurring sequoias. Both parks were created to protect these massive beauties (Kings Canyon was originally formed as General Grant National Park in 1890 for this purpose, and later expanded to include more of the surrounding wilderness).

Aside from Mist Falls in my illustration for Kings Canyon, there are other impressive waterfalls that add to the epic scenery of Kings Canyon. Roaring River Falls, as the name implies, is a 40-foot waterfall through a narrow gap in granite, creating a dramatic display of foam and froth. For a short and easy hike just off the Scenic Byway, head to Grizzly Falls. It's best viewed in spring, especially after a snowy winter, when the 75-foot waterfall will often be a rushing, thunderous wall of white water.

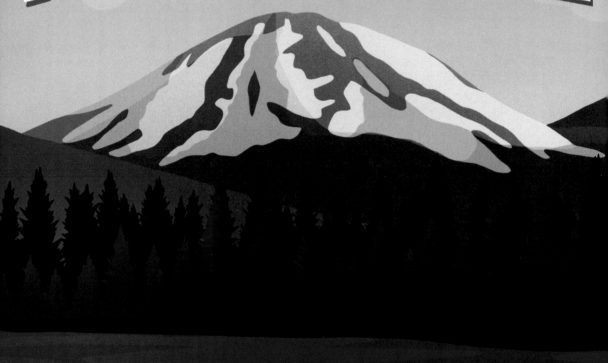

LASSEN VOLCANIC

NATIONAL PARK

CALIFORNIA ★ ESTABLISHED 1916

Given that I'm an introvert, this sounds like me whenever I go to a party, truthfully.

At Lassen Volcanic National Park, you can see all four kinds of volcanoes—shield, composite, cinder cone, and plug dome. Lassen's hydrothermal features include boiling mudpots, steaming ground, hissing fumaroles, and sulfurous gases—all accessible either by car or a short walk. If volcanoes aren't really your thing, Lassen is more than just hydrothermal activity. There are also beautiful lakes and grassy meadows filled with wildflowers in the summer. Given all of the possible activities in Lassen—hiking, biking, stargazing, camping, snowshoeing, or going for a scenic drive, for starters—it's hard to imagine not being able to find *something* to like about Lassen (unless you're this reviewer).

The Lassen region was once a hunting and meeting area for Native American tribes, including the Atsugewi, Yana, Yahi, and Maidu people. The Maidu people called Lassen Peak Kohm Yah-mah-nee, meaning "Snow Mountain." Today tribal descendants work with the National Park Service to share modern and historical tribal culture with visitors, so be sure to check out a program when you're there.

RANGER TIP: DO THE FULL MOUNT HARKNESS LOOP!

For a hike with a rewarding view, check out Mount Harkness (a shield volcano). But make sure to do the whole nine-mile loop! Most people hike the three miles to the top and then come back down the same way. But you can hike down a different three-mile descent and then three miles along the shoreline of Juniper Lake, and there's a good chance you'll have that additional six-mile stretch all to yourself!

MOUNT RAINIER

NATIONAL PARK

WASHINGTON ★ ESTABLISHED 1899

Never mind that Mount Rainier is the most topographically prominent mountain in the lower forty-eight states . . . so prominent, in fact, that locals refer to it as "the mountain," regularly noting whether it is "out" or not (meaning whether you can see it from a distance that day, depending on cloud cover).

At 14,410 feet above sea level, Mount Rainier is an absolute icon in the Washington landscape, one that towers over everything around it. It's also an active volcano, and the most glaciated peak in the contiguous United States! But when John Muir, who advocated for the preservation of Mount Rainier, said, "The mountains are calling and I must go," it was probably only bigger mountains he was referring to, right?

Several Native American tribes called the mountain variations of Tahoma, which means "mother of waters," referencing the five rivers and hundreds of waterfalls originating from the mountain. Then a random military captain sailed in and named the mountain after a different random dude who fought against the United States in the Revolutionary War. My husband and I have talked about this for twenty minutes and can't understand why this mountain is still named after this guy. Can we all just agree to call it Tahoma? I mean, "mother of waters"? Way better name.

RANGER TIP: MIND THE WILDFLOWERS, PLEASE!

The flower meadows in the springtime are stunning, but they're also fragile. Visitors step off trail for all manner of reasons, including to be nice and let people pass. While that may seem considerate, it's also important to be mindful of where you step. The growing season in the subalpine zone of a mountain is so short and the plants grow so slowly that it can take years for them to recover from the damage of a single boot print.

MUIR WOODS

NATIONAL MONUMENT

Muir Woods is just your standard forest, full of towering 600- to 1,200-year-old coast redwoods that can make a human being feel like an ant, right?

Muir Woods National Monument is part of Golden Gate National Recreation Area, north of San Francisco. The West Coast's natural scenery, including redwood forests like the ones protected within the park, so inspired John Muir that he became a fierce advocate for the preservation of America's public lands. Muir, who is often referred to as the "Father of the National Parks," explored much of the wilderness in California, the Pacific Northwest, and even Alaska in the 1860s and '70s; cofounded the Sierra Club; and played a major role in the formation of Yosemite. His preservation efforts resulted in many tributes and honors, including having Muir Woods National Monument named after him. The towering, stoic trees and quiet solitude of this park provide such stillness that one of the most popular areas of the park is known as Cathedral Grove (but despite what some visitors reportedly expect, there are no buildings, church bells, or organs to be found in this pristine grove of spectacular trees).

The 554 acres of coast redwood, Douglas fir, tanoak, and bigleaf maple were so disappointing to this particular reviewer, they also felt the need to clarify that while their rating indicates a single star, they'd "actually rate it about half or three quarters" of a star. I'd personally recommend taking a trip out to California to make up your own mind rather than taking their word for it.

"Climb the mountains and get their good tidings. Nature's peace will flow into you as sunshine flows into trees. The winds will blow their own freshness into you and the storms their energy, while cares will drop off like autumn leaves."

—JOHN MUIR

NORTH CASCADES

NATIONAL PARK

The one thing missing that could *really* set North Cascades apart and make it more interesting is a beach.

North Cascades National Park, often called the American Alps, is a massive wilderness just a few hours outside of Seattle, chock-full of mountains, rivers, and valleys (with those trees, snow, etc.). The park is a rugged and remote beauty, with jagged peaks, deep forests, tons of cascading waterfalls—this is where the Cascade Range gets its name—plus over three hundred glaciers, more than any other park in the United States outside of Alaska!

The best time to visit the North Cascades is from mid-June to late September, when the weather is mild enough for a hike. But autumn and spring are also a great time to explore by car. Layers are key for this trip no matter what time of year you visit, and remember, the higher your elevation, the more likely you are to encounter some snow. In the summer, the park offers ranger-led programs, and the North Cascades Institute helps visitors learn about both the natural and cultural history of the area. The North Cascades are the ancestral homeland of many Native Nations, including the Upper Skagit, Sauk-Suiattle, Colville, Yakama, and Nooksack people, who were forced out by treaties during western settlement and the gold rush.

RANGER TIP: A BEAUTIFUL BUT REMOTE WILDERNESS

North Cascades is a very remote park, thanks to the incredibly steep mountains that make it difficult to establish roads. While Diablo Lake is stunning, there's much more to see if you plan ahead. To make the most of your trip, do some research and set aside ample time, as the main road through the park is a six-hour drive out and back. While the drive is stunning, to truly appreciate the full beauty North Cascades has to offer, you'll also need to be prepared to hike.

OLYMPIC
NATIONAL PARK

If a park that spans so many different ecosystems that it's practically four parks in one AND is also full of incredible views doesn't wow you, I'm not sure what will.

With a huge variety of ecosystems and geography within its boundaries, the range of experiences you can have is definitely the biggest wow factor of Olympic National Park. The park spans nearly a million acres and protects a massive wilderness with several distinctly different environments, including mountains, massive glaciers, a temperate rainforest, and over seventy miles of rugged coastline. This is a real choose-your-own-adventure kind of park, no matter what sort of activity you're into. If you enjoy wildlife, you can look for humpback whales swimming off the coast, explore the colorful marine life in the tide pools, carefully avoid ten-inch banana slugs in the Hoh rainforest (I cannot tell you how many people mentioned the slugs to me when talking about Olympic!), or look for the endemic Olympic marmot in the meadows.

Let's take a look at the distinct ecosystems within Olympic (and yes, you can potentially see all four in one jam-packed day!).

First up is the coast. Olympic contains 73 miles of rugged Washington coast, featuring arches, sea stacks, and steep, rocky cliffsides; tide pools full of sea stars, hermit crabs, and anemones; and larger wildlife like sea otters, sea lions, seals, and whales. The perfect spot for a scenic coastal hike or drive!

In lower elevations, like the Elwha, Staircase, and Sol Duc areas, you'll find lowland forest. These areas are full of old growth forests of Douglas fir and western hemlock. You'll also find plenty of rivers and lakes here, including Lake Crescent, a deep, glacially-carved lake surrounded by several great hiking trails.

In the Quinault, Queets, Hoh, and Bogachiel river valleys, temperate rainforest abounds, which you can explore via hiking trails and access roads. The rainforests in Olympic National Park are some of the most spectacular temperate rainforests left in the lower forty-eight states—the forest used to extend into southern Oregon and southeast Alaska, but there isn't much left outside this protected area.

Lastly, we have the mountains—most famously, the 7,980-foot summit of Mount Olympus. The Olympic range is young and is still getting taller, thanks to tectonic plate

movements! Hurricane Ridge is a great place for panoramic views. Most peaks don't have trails to their summits, as they are technical climbs, but the park's trails will take you to several passes and lakes below the summits.

With countless opportunities to hike, climb, fish, backpack, camp, kayak, canoe, and more, it would probably be easier to tell you what you *can't* do in Olympic than to list out what you can. If there's no wow factor in this park for you, it definitely sounds like a "you" problem, not an Olympic one!

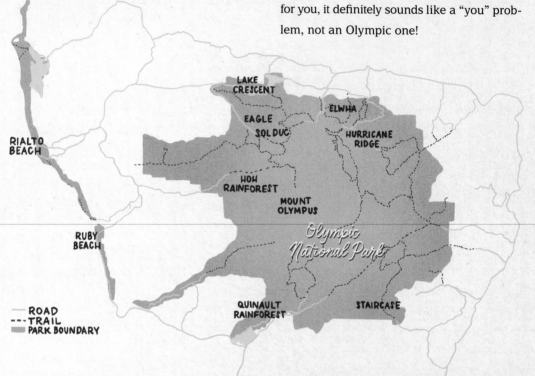

LAKE CRESCENT

ELWHA

EAGLE

SOL DUC

HURRICANE RIDGE

RIALTO BEACH

HOH RAINFOREST

MOUNT OLYMPUS

RUBY BEACH

Olympic National Park

—— ROAD
--- TRAIL
▬ PARK BOUNDARY

QUINAULT RAINFOREST

STAIRCASE

TRUE RANGER STORY: UP CLOSE AND PERSONAL

"One day I was working up at Hurricane Ridge. The subalpine meadows are very delicate, so they require people to stay on the trails. One day I walked outside and I noticed a rather large group of people all in one spot, many off the trail. I initially went to kindly ask them to move back to the trail, when I saw what they were looking at. There was a female deer in the process of giving birth. I was able to bring them back to a respectable distance and get them off the fragile meadow. After that, I and maybe thirty other people watched as this mother gave birth to two fawns. Less than ten minutes later these newborns were up and moving. I love that these visitors had the chance to witness such a beautiful moment."

DON'T UNDERSTAND WHAT ALL THE FUSS IS ABOUT

PINNACLES

NATIONAL PARK

CALIFORNIA ★ ESTABLISHED 2013

All of earth is a giant rock, so what's interesting about a bunch of smaller rocks?

Pinnacles National Park is the result of an ancient volcanic eruption. The pinnacle formations the park is named for are volcanic rock, eroded by wind and weather over millions of years. More than thirty miles of trails wind around the rock formations, rewarding hikers with spectacular views and a variety of wildlife, including golden eagles, falcons, and the elusive California condor. This bunch of rocks is also a popular destination for climbers.

Pinnacles is also home to many talus caves, which are different from a typical cave. Over thousands of years, water eroded deep and narrow canyons in the rock formations, and when huge boulders fell into the canyons, some were too big to fit and ended up forming a roof and creating the rocky talus caves. These caves are sometimes closed due to flooding or to protect the bats that inhabit them, so check their status ahead of time if you plan to explore them on your trip.

RANGER TIP: YOUR DAILY REMINDER THAT WILDLIFE IS, IN FACT, WILD

Visitors to Pinnacles often think the park keeps its California condors confined and lets them out in certain places or at certain times of day, but like all park animals, they are free to roam. The condors often go back and forth between Pinnacles and Big Sur, and can travel one hundred miles a day while foraging, so they can be difficult to spot! For a good chance of seeing them at Pinnacles, head to the west side of the park, where they're known to hang around more frequently.

REDWOOD

NATIONAL PARK

CALIFORNIA ★ ESTABLISHED 1968

I went to a coastal forest park and all I saw was the coast and forest. Once again we see that some visitors will never be happy, even when a park delivers on exactly what it promises!

Redwood National Park protects 45 percent of the world's remaining coastal redwood forests—the tallest and among the oldest in the world. The massive trees have blown people's minds for centuries. But apparently some people are not so impressed with them! The parks also protect oak woodlands, wild riverways, and nearly forty miles of rugged coastline, so I guess it's fair to say trees and coasts are mostly it, though that sounds like quite the understatement to me!

The trees and coasts of Redwood are connected in ways you may not realize. The summer fog on the coast provides nitrogen to the trees, especially those at the forest edge, and affects their growth and function. Big trees and big fish—coast redwoods and salmon—depend on each other. Redwoods help to maintain the cool, clear streams that salmon need by slowing erosion that would otherwise cause suffocating sediment in the streams and by shading the water, keeping them cool. When redwoods die, they often fall into streams, creating calm pools where fish take refuge from predators and currents. In turn, salmon supply redwoods and other plants with nutrients from their bodies after they die in these streams.

RANGER TIP: GET OFF THE BEATEN PATH

While most travelers drive straight through the park, the side roads are where you'll find the best and most secluded areas. Most people come to see the most famous, the biggest, or the oldest trees, like Big Tree (68 feet around and 1,500 years old), Tall Tree (367 feet tall until the top ten feet died in the 1990s), and Hyperion (380 feet tall, currently the tallest known living tree), which leaves the lesser-known areas less populated. Some of the most spectacular trees are found if you turn off Highway 101 onto other roads, like Howland Hill Road. For another unique vantage point, if you have time, visit the park via kayak to really see how the coast and forests interact.

SEQUOIA

NATIONAL PARK

CALIFORNIA ★ ESTABLISHED 1890

Bugs? Outside? In nature? No thank you, please.

For most people, it's captivating and magical wandering through the largest trees on earth in Sequoia National Park. (And I mean literally through them—there is a fallen tree known as Tunnel Log that you can drive through.) For others, it can be tough to get past the insects you have to share the space with, although ironically, one ranger shared with me that while working in Sequoia, they encountered the fewest bugs of any park!

Our country's second national park, Sequoia was the first park created to protect a living organism—its namesake trees, of course! Giant sequoia trees live up to three thousand years, and can grow as tall as a twenty-six-story building, averaging between 180 and 250 feet tall and up to 30 feet in diameter. The most famous tree in the park is the General Sherman, the world's largest tree, towering at 275 feet tall and 36 feet in diameter.

If the oldest and largest trees on the planet aren't enough to distract you from a few bugs, Sequoia is also home to the tallest mountain in the lower forty-eight states. Mount Whitney, standing at 14,494 feet, lies on the border of Sequoia National Park and Inyo National Forest. So if a hike through mystifying large trees, a bucket list climb up a 14er (a peak exceeding 14,000 feet), or an epic walk up the 350 steps to the top of Moro Rock for a view of the Great Western Divide sounds like your cup of tea, it's probably worth braving some bug bites for!

TREES BLOCK *view*

AND THERE ARE TOO MANY GRAY ROCKS

YOSEMITE

NATIONAL PARK

CALIFORNIA ★ ESTABLISHED 1890

Please get a more sophisticated color palette and do something about all of these trees, Yosemite. I know you sparked the idea for national parks and all, but you're kind of resting on your laurels, aren't you?

Yosemite National Park is probably best known for its epic (and, yes, gray) rock formations like Half Dome and El Capitan. Both have been popular in the climbing community for decades, but El Capitan gained mainstream attention in 2017 when Alex Honnold successfully climbed the three-thousand-foot wall in just under four hours with no ropes at all. (You read that right—my hands have never been sweatier than when watching *Free Solo*!) If you visit the area during climbing season, you'll almost certainly be able to spot climbers somewhere on the wall, even camping along the way on platforms called portaledges.

Beyond being a haven for climbers, Yosemite is full of massive valleys, wide-open meadows, giant sequoias, and epic waterfalls. An important thing to know about the waterfalls, though, is that they don't run year-round. If you visit between July and October, you probably won't see them unless it's been a particularly wet year (and no, the rangers don't turn them on and off— Mother Nature is in charge of that one!).

Yosemite was not the first place to gain the designation of National Park, but its initial protection as a wilderness area is what sparked the idea for national parks. In 1864, years before Yellowstone became our first national park, President Lincoln signed the Yosemite Grant Act, formally protecting Yosemite Valley and the Mariposa Grove. This was the first time land was protected so people could enjoy its natural beauty, setting the stage for the many national parks we know and love today.

RANGER TIP: THE MEADOWS ARE WHERE IT'S AT

Admittedly, the trees in Yosemite *do* make it somewhat difficult to find a good vantage point to see all of Yosemite Valley from. For the best bang for your buck, visit Cooks Meadow. It's almost the center of the valley, so you get to see all of the big things most people come to visit, like Half Dome, Yosemite Falls, and Sentinel Rock. Plus, it's a super easy half-mile loop! But if you're looking for a less crowded spot to go, check out Tuolumne Meadows for wide-open spaces with views of many peaks and almost no crowds.

"Yosemite Valley, to me, is always a sunrise, a glitter of green and golden wonder in a vast edifice of stone and space."

—ANSEL ADAMS

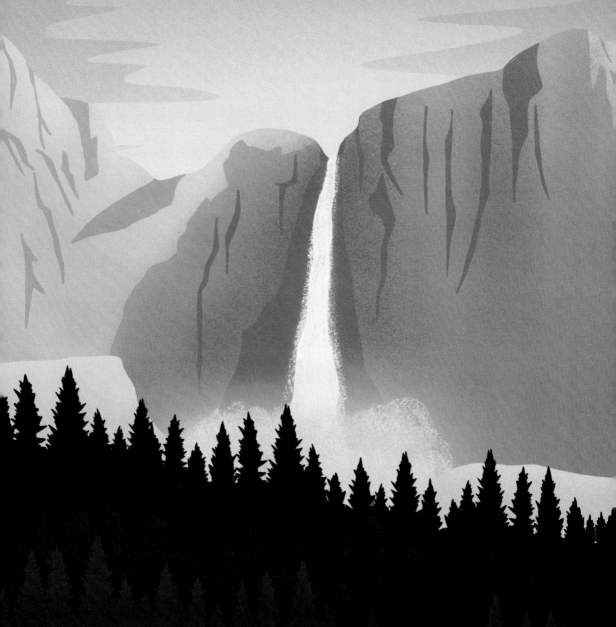

FALLS WERE NOT

THAT FANTASTIC

GLACIER

YELLOWSTONE

Montana

DEVILS
TOWER

GRAND TETON

Wyoming

Utah

CAPITOL
REEF

ARCHES

ROCKY
MOUNTAIN

BRYCE
CANYON

CANYONLANDS

BLACK CANYON
OF THE GUNNISON

ZION

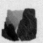

GLEN
CANYON

MESA VERDE

GREAT SAND
DUNES

Colorado

GRAND CANYON

New Mexico

PETRIFIED FOREST

Arizona

SAGUARO

WHITE SANDS

CARLSBAD
CAVERNS

Tex

GUADALUPE
MOUNTAINS

BIG BEND

INTERMOUNTAIN

The NPS Intermountain Region is responsible for areas in Arizona, Colorado, New Mexico, Montana, Oklahoma, Texas, Utah, and Wyoming, managing fifty-five sites. Home to some of the most well-known (and well-visited) parks, it's the kind of area that typically comes to mind when you think of a national park. It's also where the geographic diversity of the United States is on full display, from sprawling deserts to massive canyons, towering mountains, thermal features, and abundant wildlife. Of course all of that hype leads to more than a few disappointed visitors!

ARCHES

NATIONAL PARK

UTAH ★ ESTABLISHED 1971

Apparently license plates are our new standard for natural beauty.

Arches National Park has been disappointing visitors since 1996, when Utah first debuted Delicate Arch on its license plate. Arches was named a national monument in 1929, and was redesignated as a national park in 1971. With over two thousand arches across 119.8 square miles, the park features the largest concentration of natural sandstone arches in the world! While most of the well-known arches here are freestanding, there are actually three other types of arches to be found in the park: cliff-wall arches, pothole, and natural bridges.

Landscape Arch, spanning 306 feet, is the fourth longest arch in the world. You can also find the tallest opening to an arch at Double Arch, in the Windows area of the park, standing at 112 feet!

While Arches is obviously best known for these namesake formations, the park is also home to other incredible geology, including pinnacles, fins, and balanced rocks, as well as plenty of desert wildlife and plants.

Aside from the arches, Balanced Rock (pictured on the next page) is one of the better-known features in the park. The enormous sandstone boulder atop Balanced Rock is estimated to weigh about 3,600 tons, and someday it will come tumbling down as its base continues to erode. In the winter of 1975–76, the balanced rock next to it, known as Chip-Off-the-Old-Block, fell, so plan to check out Balanced Rock sooner rather than later! Then and now photo comparisons on the park service's website show just how much these rocks have changed in recent years, so it's definitely a park to continue to revisit to see its ever-changing landscape.

But, I suppose, when you compare all of that to the breathtaking beauty of a license plate . . .

"A forest is mystery, but the desert is truth. Life pared to the bone."

—KEITH MILLER

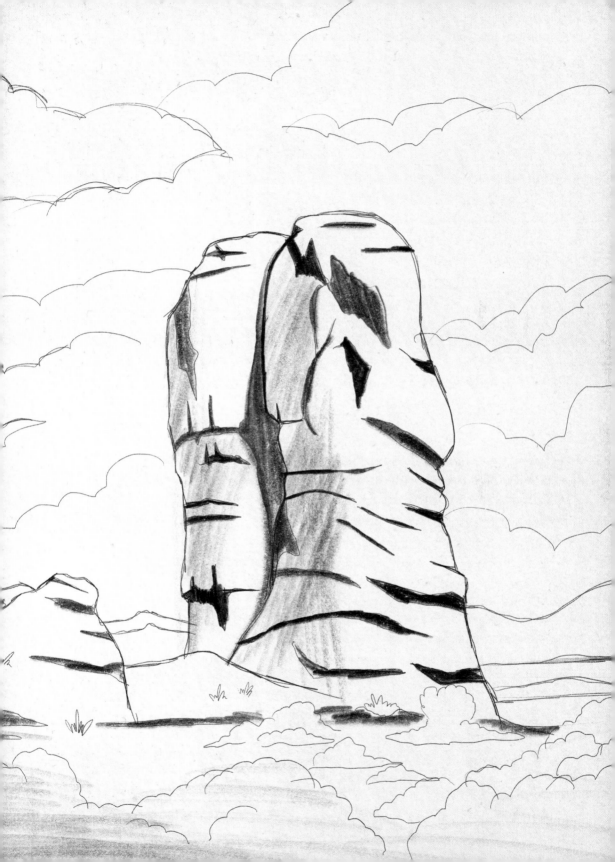

BIG BEND
NATIONAL PARK

The Chihuahuan Desert *IS* the wettest of all four deserts in North America, after all!

Named for a wide bend in the Rio Grande river, Big Bend National Park has deep canyons carved by the river, plus gorgeous desert and mountain scenes. Thanks to the Rio Grande, the park has lots of vegetation and wildlife, and boasts more types of birds, bats, butterflies, ants, scorpions, and cacti than any other national park in the United States!

Like many US national parks, Big Bend is an International Dark Sky Park. But Big Bend lays claim to the darkest measured skies in the lower forty-eight states. It's also one of the most remote and least visited national parks in the lower forty-eight, so head here for epic stargazing and low crowds.

RANGER TIP: DON'T MESS AROUND WITH THE HEAT!

Many visitors want to hike in the Chisos Mountains because the higher elevations are cooler and offer some shade. The trailheads are often overcrowded, and it can be hard to find parking, especially at the Lost Mine Trail. Try the trails along Ross Maxwell Scenic Drive. They are lower in elevation, so they can be a bit warmer, but many of them lead through cool canyons or end up at springs with shade trees. Just be careful not to overexert yourself. The heat can make you sick even if you are very fit or even if you are not hiking very far, and heat illness creeps up quickly. Take it easy in the sun, seek shade, drink water when you're thirsty, and eat salty snacks when you're sweating.

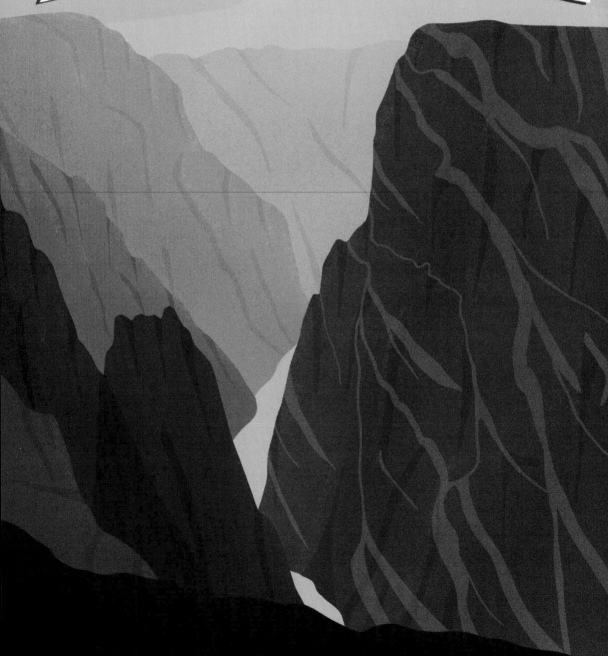

BLACK CANYON
OF THE
GUNNISON
NATIONAL PARK

COLORADO ★ ESTABLISHED 1999

Just a canyon created over the course of two million years, exposing mind-blowing patterns of rock that are over two billion years old. Nothing interesting here.

Black Canyon of the Gunnison is so named because the huge canyon walls are often covered in shadows and receive so little sunlight that they look black. Some of the deepest parts of the gorge are barely reached by sunlight every day. Over two million years, weather and the Gunnison River worked together to sculpt the walls into some of the steepest cliffs in North America! Painted Wall, the park's most well-known feature, stands 2,250 feet up from the river and is Colorado's tallest cliff. The iconic veiny white streaks in the wall are a type of granite called pegmatite.

Members of the Ute tribe, who today live on the southern border of Colorado, were the first to make their homes in the Black Canyon area centuries before white explorers reached it and forced them out, but the canyon is so steep and deep that evidence shows that even they lived only along the rim and nowhere in the gorge below. Supposedly, they referred to the Gunnison River below them as "much rocks, big water," highlighting the dangers awaiting you at the bottom of the canyon.

"Within National Parks is room—glorious room—room in which to find ourselves, in which to think and hope, to dream and plan, to rest and resolve."

—ENOS MILLS

BRYCE CANYON

NATIONAL PARK

UTAH ★ ESTABLISHED 1928

I might be biased here, since orange is my favorite color, but I fail to see how any canyon could ever be too orange.

Bryce Canyon National Park is famous for being the largest collection of hoodoos—distinctive, spiky (and, yes, orange in this case) rock formations—in the world. Walking through the park feels like traveling to a different planet. I hiked the aptly named Fairyland Loop in 2019, which meanders through a variety of scenery within the park and feels like pure fairy-tale magic, and I'm already eagerly planning my next trip back.

It might surprise you to learn that Bryce Canyon is not technically a canyon at all! It's actually a series of amphitheaters carved by millions of years of erosion. Canyons, like the Grand Canyon, are formed through erosion by a central river or stream. Bryce Canyon was formed by a different process called headward erosion, and the iconic hoodoo formations were formed by ice wedging, where water seeps into cracks in the rocks and expands when it freezes.

A HELL OF A PLACE TO LOSE A COW

This reviewer wasn't the only person unimpressed by Bryce Canyon. Rancher Ebenezer Bryce was not a fan of the area that is now Bryce Canyon, which ran through his 1870s ranch, and once famously called it "a hell of a place to lose a cow." Members of the Paiute tribe, who lived and hunted in the area around what is now Bryce Canyon starting around 1200 AD, had much more reverence for the canyon.

According to Paiute legend, the hoodoos were created by Coyote, who turned the To-when-an-ung-wa ("Legend People") into the rocks because they were gluttonous and took too heavily from the land. The hoodoos are believed to be their faces. Since Ebenezer Bryce wasn't a big fan of this park, count me in for renaming this amazing place after the Paiute legends!

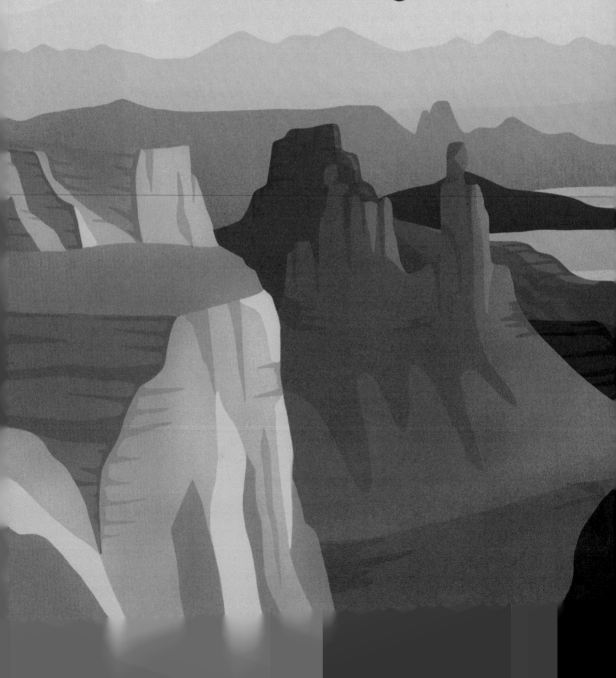

A DISAPPOINTMENT
to us

CANYONLANDS

NATIONAL PARK

UTAH ★ ESTABLISHED 1964

This reviewer isn't mad. She's just disappointed. But looking at the wide-open vistas and dramatic layers of striated red-orange canyon walls, it's hard to imagine how!

Covering over five hundred square miles of colorful canyon landscape with mesas, buttes, and arches, Canyonlands National Park is Utah's largest national park. The Colorado and Green Rivers divide the park into four districts.

Island in the Sky is the most accessible part of the park, offering views from overlooks along the paved scenic drive, hikes of varying lengths, and a moderate four-wheel-drive route, White Rim Road. It's home to the famous Mesa Arch, a popular sunrise photography spot!

The Needles offers opportunities for a backcountry experience, requiring hiking and/or four-wheel driving to see the attractions.

The Maze is a remote district requiring more time and self-reliance—and a four-wheel-drive, high-clearance vehicle. Roads are difficult to navigate, and hikes are challenging.

The Rivers district is . . . well, rivers! Above the confluence, the water is perfect for canoes and kayaks. Below, the combined river flow creates a fourteen-mile stretch of whitewater down Cataract Canyon.

CAPITOL REEF
NATIONAL PARK

UTAH ★ ESTABLISHED 1971

On the bright side, at least this person wasn't confused about Capitol Reef not being a coral reef in the middle of land-locked Utah.

Capitol Reef is one of Utah's less-visited national parks, but don't think that means it's not worth a trip. (It still gets 1.2 million visitors per year, after all!) It's filled with cliffs, canyons, domes, and bridges, and whether you're in the mood to explore on foot or in a car, plenty of red-rock beauty awaits you.

The Ute tribe referred to the area as the land of the sleeping rainbow because of the combination of the multicolored sandstone, green vegetation, and blue skies. Early American settlers noted that the white domes of Navajo Sandstone resemble the dome of the Capitol Building in Washington, DC. (One of the formations is still called Capitol Dome to this day.) Waterpocket Fold, an eighty-seven-mile-long ridge, was often referred to as a reef, since it was a large barrier to transportation across the area (although, unlike the Guadalupe Mountains, which we'll get to in a bit, this area was never actually a reef). These two observations combined is where the park gets its name!

WHAT'S THE DEAL WITH THE FRUIT?

Mormon settlers planted fruit orchards in the area in the 1880s. The orchards are managed to preserve their historic character and are still watered with the original irrigation system. Visitors can pick and eat fruit in the orchards when in season, and purchase fruit and nuts to take along on their way. When fruit is ready to harvest, you'll see a "U-Pick Fruit" sign up!

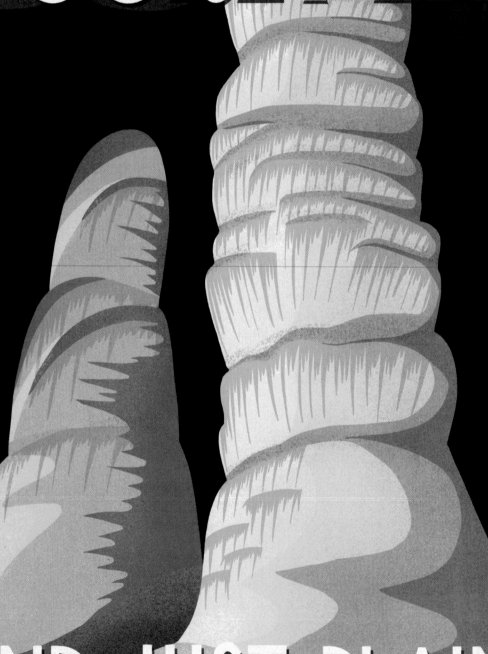

CARLSBAD CAVERNS

NATIONAL PARK

NEW MEXICO ★ ESTABLISHED 1930

These caverns have been putting the "bad" in Carlsbad since 1930. How hard would it be to hang some art and install a tasteful sconce or two?

Despite how plain the walls might look to the undiscerning eye, Carlsbad Caverns is full of decorations. Formations called speleothems that continue to grow in Carlsbad Caverns are due to rain and snowmelt soaking through limestone, eventually dripping into a cave and evaporating. When the water evaporates, it leaves behind a small amount of mineral (mostly calcite), which eventually builds up into these "decorations." Good interior design takes time!

Carlsbad has been decorating itself for more than a million years, but today few speleothems are wet and actively growing due to the increasingly dry desert climate.

One thing many people don't realize about Carlsbad Caverns is that there are plenty of things to do above ground, too! There are hiking trails through the beautiful Chihuahuan Desert sprawling out above the caves. Plus, you can hang out and watch the thousands of bats that call the caverns home leaving the cave each evening, from April to October. Every year on the third Saturday of July, the park hosts Dawn of the Bats, where visitors gather at dawn to watch swarms of bats return to the caves.

WOULD YOU RIDE A BUCKET DOWN?

Guano miners (the guano in the caves was used for fertilizer) once used a bucket to lower themselves in and out of Carlsbad Caverns. From 1923 to 1925, visitors descended into the caves via the same guano-bucket system (maybe this is why Carlsbad Caverns' original four-letter abbreviation was CACA?). Only two people could fit into the bucket at a time. Now there's a more modern elevator, which can fit up to sixteen visitors and makes the caverns much more accessible. Even with the guano, I kind of wish the bucket ride was still an option, though.

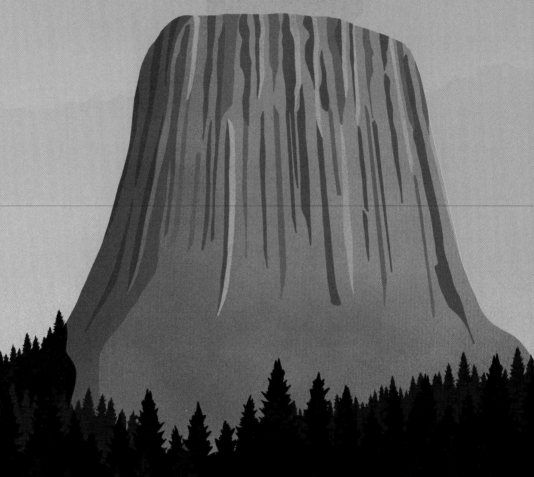

DEVILS TOWER
NATIONAL MONUMENT

The country's first national monument, Devils Tower, is just an 867-foot-tall rock.

At over four football fields in height, the tower juts out of the relatively flat surrounding prairie, and hundreds of parallel cracks make it one of the finest crack-climbing areas in North America. The lack of an apostrophe here is often thought to be a mistake, as it was referred to as *Devil's* Tower, but the US Board of Geographic Names advises against using apostrophes in names, so the document signed by Teddy Roosevelt (reminder: presidents can form national monuments by executive order) formed Devils Tower National Monument, sans apostrophe. All this bureaucratic silliness aside, this is another park where a rename seems like an obvious idea to me—the entire reason behind naming it Devils Tower was actually a botched translation of the Lakota term for the formation. Colonel Richard Irving Dodge led an expedition through the area in 1875, and his interpreter mistranslated the name Mato Teepee, calling it "Bad God's Tower," which was eventually reworded to Devils Tower. What the local tribes actually call it is . . .

BEARS LODGE, HOUSE, OR LAIR

Bears are a common thread among the indigenous tribal stories about the origins of this iconic butte, and most indigenous names for the tower reference bears. A Kiowa legend tells of seven girls who were attacked by bears. One of the girls prayed to the rock for help and the rock began to grow, pushing the girls out of the bears' reach. When the bears jumped to reach the girls, they fell to the ground, scratching the rock and creating the deep grooves you see in the butte. Modern tribal connections are kept alive through traditions and ceremonies practiced by many tribes at the monument. Prayer offerings (colorful cloth bundles with medicinal herbs) can be seen along the park's trails—if you see them, don't disturb them! Given the sacred significance of the land and the absolute meaninglessness of the current name, Bear Lodge National Monument has a nice ring to it, if you ask me.

GLACIER
NATIONAL PARK

MONTANA ★ ESTABLISHED 1910

Apparently calling the park Glacier wasn't a strong enough hint as to the climate of the area.

Often called the Crown of the Continent, a nickname coined by George Bird Grinnell, who advocated for the preservation of the park, Glacier National Park gets its name from the glaciers that formed its impressive peaks and valleys over thousands of years, and the more than a dozen glaciers the area is still home to. It's a land of lush forests, rugged mountains, alpine meadows, and pristine lakes, and a natural habitat for bighorn sheep, elk, lynx, black bears, and one of the largest grizzly bear populations in the lower forty-eight states (yes, bear spray is a must!).

With over seven hundred miles of trails, Glacier has plenty to do for anyone looking for some alone time in the wilderness, but it's a well-trafficked park, so you'll need to do a little research to avoid the crowds. With over three million visitors every year, popular spots like Saint Mary Lake, the Highline Trail, and Hidden Lake are likely to include a steady stream of people, some of whom will inevitably be complaining about the temperature (which averages 25 to 55 degrees, including in summer).

One of the most popular pastimes in the park is traveling up the epic Going-to-the-Sun Road, a 50-mile scenic drive that takes at least two hours. The road was completed in 1932, and you might recognize it from the opening credits of *The Shining* or from a part of Forrest Gump's cross-country run! The Going-to-the-Sun Road connects the lakes McDonald and St. Mary and climbs up Logan Pass along the way, capping out at 6,646 feet, right along the Continental Divide. While portions of the road remain open all year, the alpine stretch of the road is open only from June or July until early October, depending on snowfall and plowing progress. Along the road you'll find three visitor centers (Apgar, Logan Pass, and St. Mary), five campgrounds, and access to endless hiking trails and scenic pullouts, so you can stop and take in the incredible scenery on your way.

Beyond the natural wonders of the area, there's plenty to learn culturally as well. Within US boundaries, Glacier is flanked by the Blackfeet Reservation to the east and

the Flathead Reservation to the west and south of the park. Native American tribes have lived in the area for over ten thousand years, using the land for hunting, fishing, ceremonies, and gathering plants, and the mountains still hold spiritual significance for the tribes. Members of the Blackfeet tribe operate tours in the park, where you can learn about the tribal customs and stories in the context of the gorgeous scenery.

KINTLA LAKE

BOWMAN LAKE

MANY GLACIER

Glacier National Park

LOGAN PASS

ST. MARY LAKE

LAKE MCDONALD

APGAR

TWO MEDICINE

ROAD
- - - TRAIL
PARK BOUNDARY

RANGER TIP: IT'S NOT REALLY *THAT* COLD

A lot of people think the only time to visit Glacier is in July and August and that every other month the park is covered with snow and inaccessible. While the higher-elevation areas of the Going-to-the-Sun Road typically close from mid-October to June, snow melts in most of the park by March and usually doesn't form a solid snowpack again until early January. February is probably the only month when there is truly consistent snow.

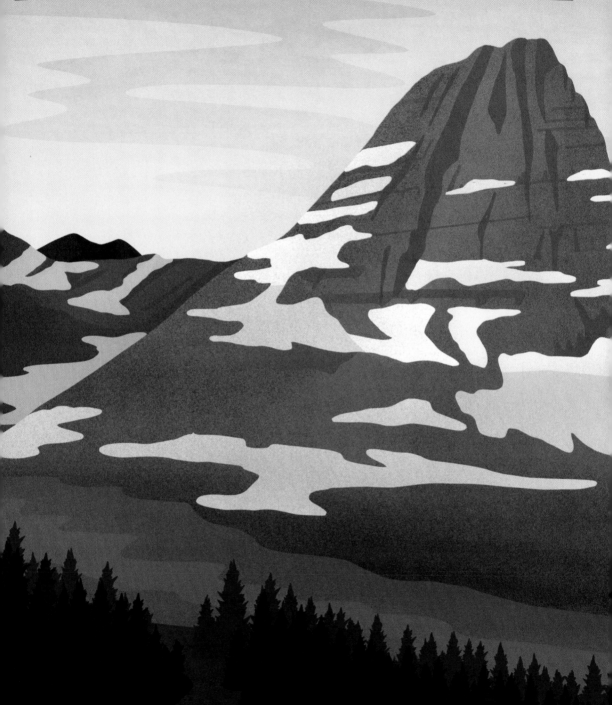

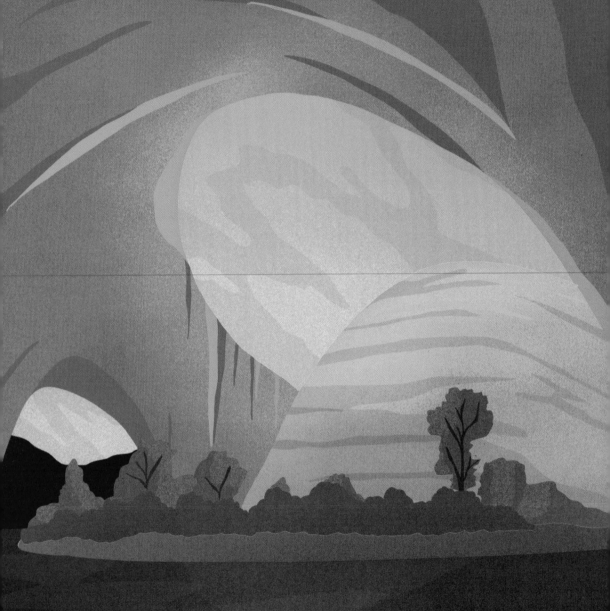

GLEN CANYON

NATIONAL RECREATION AREA

UTAH AND ARIZONA ★ ESTABLISHED 1972

File this review under "technically true, but a massive undersell."

Encompassing over a million acres, Glen Canyon National Recreation Area offers amazing opportunities for water and backcountry recreation. Stretching for hundreds of miles from Lees Ferry in Arizona up into southern Utah, Glen Canyon includes scenic vistas, gorgeous canyons to explore, and Lake Powell, one of the largest man-made reservoirs in North America (and a stand-up paddler or kayaker's dream, since you can paddle right into narrow slot canyons!). Lake Powell was formed by the flooding of the Glen Canyon area thanks to Glen Canyon Dam, used for recreation, power generation, and delivering water to California, Arizona, and Nevada.

Glen Canyon is much more than Horseshoe Bend and Lake Powell, stunning though they may be. To escape the crowds, you'll want to look a bit deeper, but go off the beaten path and you'll be rewarded with towering canyon walls, wide-open vistas, stunning arches, and few other people on the trail.

WHAT TIME IS IT?

Depending on the time of year, this question is tougher than it seems! Straddling both Utah and Arizona, Glen Canyon follows Arizona time, which is Mountain Standard Time year-round—no daylight saving time here! However, within Arizona, the Navajo Nation *does* switch to daylight saving time. But within the Navajo Nation is the Hopi Reservation, which *does not* switch to daylight saving time. Utah *does* switch to daylight saving time, with the exception of Dangling Rope Marina, which is in Utah but runs on Arizona time and does *not* switch to daylight saving time. The roads continually cross these borders, and your phone might even be pinging a tower across a border from you, so your smartphone clock will constantly be changing. Pro tip from personal experience: set your car clock to the time zone you need to keep track of!

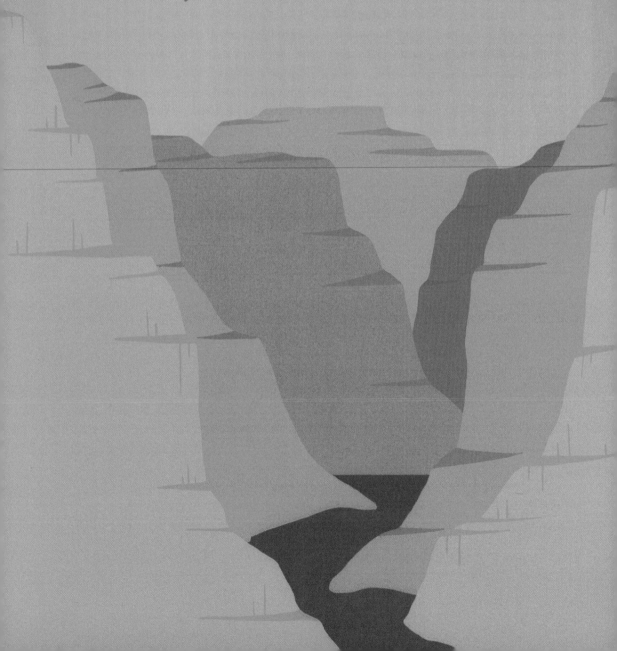

GRAND CANYON
NATIONAL PARK

ARIZONA ★ ESTABLISHED 1919

Of all the reviews I've seen during this project, no sentiment was repeated across several reviews as often as this take on the Grand Canyon. That anyone— never mind multiple anyones— could leave with this impression after looking down at the massive, 277-mile-long, 18-mile-wide, 1-mile-deep Grand Canyon, full of richly colored layers of rock that go on as far as you can see, boggles my mind.

I first visited at age ten and immediately wanted to head to the bottom. At age twenty-nine, I finally did and am happy to report that it's decidedly not just a very large hole. It's much more alive than you'd realize from the rim, with the Colorado River and its tributaries creating an oasis of vegetation for wildlife, including bighorn sheep, mountain lions, coyotes, and the pesky rock squirrel, which is often referred to as the most dangerous animal in the park—dozens of visitors are bitten each year trying to feed them. After spending a significant amount of time ensuring our supplies were safe from the squirrels while backpacking, I can confirm they were the biggest concern of our trip.

RANGER TIP: FOR FEWER CROWDS, CHECK OUT THE NORTH RIM

It would take many lifetimes to know all of the canyon, as there are a million places that are spectacular and very hard to get to. But to start, visit the North Rim, which gets just 10 percent of total park visitors and is an entirely different world from the highly visited South Rim. Full of tall trees, snow, and not much infrastructure, it's a great way to escape the crowds. Note: the road to the North Rim is typically closed from mid-November to mid-May, thanks to the aforementioned snow. If you stay on the South Rim, check out the Desert View Watchtower toward the eastern entrance— it's a unique view of the park with fewer people, and a fun building to explore.

GRAND TETON
NATIONAL PARK

WYOMING ★ ESTABLISHED 1929

This reviewer visited Grand Teton National Park, and all they saw was...exactly what was promised.

It's not hard to figure out what you'll find at Grand Teton National Park. Just google it, and you'll be inundated with gorgeous views of said mountains, trees, and massive bodies of water, so I'm not sure what else you could want! But if that's not enough for you, the park is also home to the fastest land mammal in the Western Hemisphere, the pronghorn. It can run up to seventy miles per hour, though, so blink and you might miss it!

The park's most distinctive feature, the forty-mile-long Teton Range, creates an instantly recognizable skyline. At ten million years old, it's the youngest range in the Rocky Mountains (in fact, they're some of the youngest mountains in the world), but they make quite a statement! While the mountains are new, much of the rock here is far from it—gneiss, a type of rock with distinct banding patterns that develop under high temperature and pressure, is 2.7 billion years old, which makes it some of the oldest rock in North America. Indigenous tribes like the Shoshone, Bannock, Blackfeet, Crow, Flathead, Gros Ventre, and Nez Perce inhabited the land as far back as 11,000 years ago, hunting and gathering the wide variety of animals and plants that still live there today, as well as collecting rocks and minerals.

RANGER TIP: SPECTACULAR PLACES BEYOND JENNY LAKE

Jenny Lake is one of the most iconic sites of Grand Teton, but of course it's also one of the most crowded. All of the 220 miles of trails in the park offer fantastic views of mountains, lakes, and trees. The Death Canyon (maybe more people would visit it if it wasn't so grimly named), Paintbrush Canyon, and Phelps Lake trails tend to have fewer hikers than the more popular trails like Jenny Lake and Cascade Canyon.

GREAT SAND DUNES

NATIONAL PARK

I mean, it is called Great Sand Dunes, so I'm not sure what else you could expect here! It "just" has the tallest sand dunes in all of North America.

Great Sand Dunes National Park protects a collection of sand dunes formed over thousands of years on the eastern edge of the San Luis Valley in Colorado. A massive mountain of sand, the entire dune field of Great Sand Dunes National Park encompasses thirty square miles, and the tallest, Star Dune, caps out at around 750 feet. The inner child of every visitor (except for this reviewer, apparently) jumps at the opportunity to sled down the massive dunes. While sandboarding and sledding are allowed away from any vegetated areas, the park doesn't rent out any of this gear—there are places to rent gear outside the park, so plan ahead.

In addition to its mountains of swirling sand, the park also contains ecosystems ranging from wetlands to alpine lakes, tundra, ancient spruce and pine forests, and grasslands—with diverse plants and wildlife to match! Across this varied landscape you'll find opportunities for hiking, fat biking (bikes with special oversized tires for less stable terrain), camping, picnicking, and backpacking.

If all that wasn't enough to entertain you, in 2019, Great Sand Dunes became a certified International Dark Sky Park by the International Dark Sky Association. Its dry air, low light pollution, and high elevation makes it a perfect galaxy-gazing spot!

THE PARK IS OUT OF THIS WORLD

Speaking of outer space, the namesake sand dunes in the park are so otherworldly that NASA has actually used the dunes to test rovers! The dunes in the park have similar formations to dunes on Mars, and two Viking spacecraft that landed on Mars first had their mettle tested by NASA in the dunes at Great Sand Dunes.

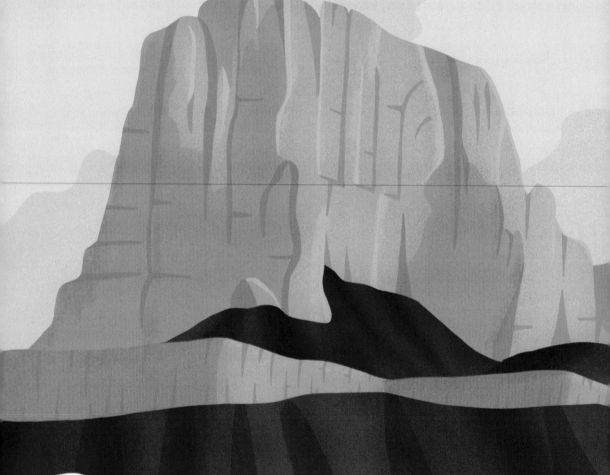

GUADALUPE MOUNTAINS

NATIONAL PARK

TEXAS ★ ESTABLISHED 1972

The highest point in Texas, the largest exposed fossil reef in the world, not to mention a diverse landscape of desert, canyon, and alpine ecosystems. MEH.

Guadalupe Mountains National Park contains the southernmost, highest part of the forty-mile-long Guadalupe mountain range. From a distance, the mountain range looks a bit like a reef running high across the desert—you might be surprised to know that the Guadalupe Mountains actually *were* part of a reef, called the Capitan Reef (not to be confused with Capitol Reef, which was never actually a reef . . . who is responsible for these naming decisions?! I'd like to speak to a manager!), that once stretched four hundred miles underwater around an ancient sea. That same sea formed Guadalupe Mountains' neighbor, Carlsbad Caverns National Park—and if you're going to visit this remote area, you might as well check out both.

Whether you're into hiking, backpacking, camping, horseback riding, birding, or wildlife watching, you'll find plenty to do here. There are over eighty miles of trails, from short day hikes to multiday undertakings, and you can meander through dry open desert, wind through McKittrick Canyon, hike Guadalupe Peak, explore Frijole Ranch, and learn about the Mescalero Apaches, the park's original inhabitants.

"If you can't be in awe of Mother Nature, there's something wrong with you."

—ALEX TREBEK

MESA VERDE

NATIONAL PARK

COLORADO ★ ESTABLISHED 1906

I guess the Ancestral Puebloan cliff dwellings, petroglyphs, and the largest archaeological preserve in the United States doesn't count as much these days.

Mesa Verde National Park was established to "preserve the works of man," the first national park for this kind of purpose. Mesa Verde is Spanish for "green table," and it's so called because of the many lush juniper and piñon trees covering the land. The park preserves archaeological sites built by the Ancestral Puebloans, who inhabited the area from 550 AD to 1300 AD.

There are nearly five thousand archaeological sites in the park, including six hundred cliff dwellings, plus pithouses (homes that are dug partly into the ground and then covered with a roof), pueblos, masonry towers, and farming structures on top of the mesa. These archaeological sites are some of the best-preserved dwellings in the United States. Plan to spend at least a day here exploring, as just getting in and out of the park will take you at least two hours, and you'll want plenty of time to explore this archaeological wonder.

A PEOPLE SHROUDED IN MYSTERY

By 1300, the Ancestral Puebloans had migrated south and Mesa Verde was left deserted, and we still don't know why. There were no written records left behind, but the abandoned dwellings and artifacts have given archaeologists clues about the Puebloan lifestyle. Most of what we've learned about their life has actually come from studying their garbage, tossed down the slope in front of their dwellings.

PETRIFIED FOREST

NATIONAL PARK

ARIZONA ★ ESTABLISHED 1962

It seems like this review might have been prevented by a little bit of research. And never mind that those "dead trees" dismissed so casually are the fossilized remains of ancient trees from two-hundred-plus million years ago, full of mind-blowing colors and patterns.

While the name Petrified Forest might make you think of towering forests made of stone, the "forests" in Petrified Forest aren't actually forests—they're logjams that are the result of a large river system. As trees died naturally or were pulled up during floods, they would float downstream. Over millions of years, the trees fossilized, and their petrified remains in these concentrated jams are now known as Crystal Forest, Blue Forest, Rainbow Forest, Jasper Forest, etc.

The brilliant colors in the petrified wood are thanks to three different minerals: pure quartz shows as white; manganese oxide creates blue, purple, black, and brown; and iron oxide is responsible for the yellow, orange, red, and brown hues. Because the edges are often smooth and precise, many visitors assume they were cut open by humans. But it's actually all natural! The logs are very hard but brittle, and after petrification, the logs cracked and broke under stress. The quartz that mostly composes the logs naturally breaks at a clean angle, giving them the look of being freshly and precisely cut.

Because the petrified wood is so beautiful and colorful, many visitors want to take rocks home with them. Don't be one of those people! (You'll face a hefty fine.) Leave the petrified wood you find for all to enjoy, and instead purchase a piece from the visitor center, which simultaneously supports the parks and is sourced legally from privately owned areas.

"Land really is the best art."

—ANDY WARHOL

ROCKY MOUNTAIN
NATIONAL PARK

I mean, other than three hundred miles of trails, ridiculous star-gazing, Trail Ridge Road, an insanely beautiful wildflower season, and hundreds of species of wildlife . . . there's really nothing impressive about the Rocky Mountains.

Rocky Mountain is one of the nation's highest national parks. With elevations from 7,860 feet to 14,259 feet, Rocky Mountain makes you feel like you are on top of the world—if that's something that's impressive to you, anyway. Approximately one-third of this national park is above the altitude where trees grow in northern Colorado (around 11,500 feet above sea level), creating the alpine tundra ecosystem.

The park crosses the Continental Divide and boasts seventy-seven mountain peaks over 12,000 feet high. There's an incredible variety of landscapes in close proximity to one another, from a maze of evergreen trees covering the mountainsides to crystal-clear lakes, fields of wildflowers, meandering rivers, and hilly slopes.

Opportunities for hiking, scenic drives, wildlife watching, camping, fishing, and backpacking abound! Between winter snowshoeing, sledding, and cross-country skiing, spring and summer wildflowers, and fall foliage with elk descending from the high country, there's something to see or do in every season. If you're not able to explore outside your vehicle, Trail Ridge Road might just be for you. It's the highest continuous paved highway in the United States—you climb 4,000 feet in just a few minutes driving it, and it caps out at 12,183 feet. Covering forty-eight miles through the park, it's an unparalleled scenic drive that twists through the gorgeous mountain wilderness.

As with many national parks, in Rocky Mountain you can roam the same paths people have traveled for thousands of years. Trail Ridge Road closely follows the route taken by Ute and Arapaho people when crossing the area themselves, and you can hike the Ute Trail in the park, a 5-mile section that follows the ridge both tribes would walk when traveling seasonally between their hunting grounds. Both tribes depended largely on buffalo, which is likely what brought them to the area.

If you're looking for a longer trek, a 30-mile stretch of the Continental Divide Na-

tional Scenic Trail runs north–south right through the center of the park. The trail follows along parts of the actual divide, an invisible border that shapes whether water flows east or west and splits the park into its eastern and western sections. The trail is a small piece of the larger Continental Divide National Scenic Trail, which extends 3,100 miles from the Canadian border in Montana all the way down to the border of Mexico in New Mexico. Just keep in mind that the lowest elevation on the part of this trail that runs through the park is 8,000 feet, so if you're not acclimated, it might feel like a tougher hike than you'd expect—the air is thin and your travel times will be slower.

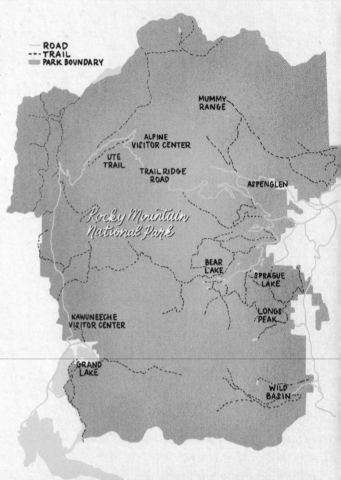

ROAD
--- TRAIL
PARK BOUNDARY

MUMMY RANGE

ALPINE VISITOR CENTER

UTE TRAIL

TRAIL RIDGE ROAD

ASPENGLEN

Rocky Mountain National Park

BEAR LAKE

SPRAGUE LAKE

LONGS PEAK

KAWUNEECHE VISITOR CENTER

GRAND LAKE

WILD BASIN

RANGER TIP: ALTITUDE ADJUSTMENT

A lot of visitors unwisely plan to hike the prominent and well-known Longs Peak after arriving from places closer to sea level, in addition to not being in the shape needed to climb it. It's not a casual undertaking, and you'll definitely want to plan and train for it because the Keyhole Route is a climb, not a hike. At 14,259 feet, Longs Peak is the highest peak in the park and can experience winter-like conditions at any time throughout the year, not to mention the aforementioned thinner air you'll experience at very high altitude. Even at the relatively lower elevations in the park (which are still high!), the need for altitude adjustment is real and should not be ignored. If you live in a lower altitude, make sure to drink a lot of water and take your time, especially if you plan to go to high-altitude areas like Trail Ridge Road and the hikes along it.

OK IF YOU LIKE
cactus

SAGUARO
NATIONAL PARK

ARIZONA ★ ESTABLISHED 1994

I don't really know why you'd go to a park called Saguaro if you didn't like cacti. Saguaro National Park is a beacon for truth in advertising, in addition to being the universal symbol for the West.

The majestic saguaro, North America's largest cactus, can grow as high as fifty feet tall and live longer than two hundred years. They're so tall, they tower over the surrounding vegetation and are often referred to as the "king of the cactuses."

Saguaro National Park protects 150 square miles split into two separate areas, one east of Tucson and one west of it. The varied mountain and desert landscapes in Saguaro provide ideal habitats for a wide range of wildlife, such as coyote, quail, javelina, and tortoise in the lower elevations, and deer, black bear, and the Mexican spotted owl in the upper elevations.

Saguaro is also the ancestral home of the Tohono O'odham people, who continue to visit every year in the early summer to pick saguaro fruit. They utilize pretty much every part of the saguaro, using the thorns, burls, ribs, flowers, fruit, and seeds for fiber, manufacture, trade, and food, including a ceremonial wine. This wine is drunk during Nawait I'i, a rain ceremony held during the monsoon season as part of a cleansing ritual involving singing, dancing, and speeches to summon the clouds. The saguaro are sacred to Tohono O'odham people, and the harvest marks the beginning of their new year. Because the saguaro are believed to be their ancestral people, the Tohono O'odham tribe believes you must never harm a saguaro and must gather the fruit in a respectful way.

If you want to see the saguaros in bloom, visit in May or June. Their white, waxy flowers open at night and close in the morning, so plan accordingly!

LITERALLY MILES OF

WHITE SAND

WHITE SANDS

NATIONAL PARK

NEW MEXICO ★ ESTABLISHED 2019

Although it seems to be a common theme across many reviews, vilifying a park for being exactly what it claims to be feels a little unfair—not to mention that given the unique and rare nature of this particular sand, calling it "white sand" to begin with feels like an undersell! (We'll get to that.) In White Sands, 275 square miles of dazzling white dunes sprawl out to welcome park visitors.

The miles of white sand in White Sands National Park are a bit of a wonder, and the park's simple name belies how interesting these dunes are. There are only a few places in the world where you can find this rare kind of sand, particularly in quantities big enough to form dunes. While grain size is the only thing that really defines a material as sand, most sand on earth is silica, formed from quartz, but White Sands is formed from gypsum. Gypsum is actually clear but easily scratched, and the scratches on the surface of the grains make it reflect the sun and appear white.

And these dunes do, in fact, stretch on for miles. White Sands is the largest gypsum dune field in the world! Gypsum dissolves in contact with water, but the isolation and weather of the Tularosa Basin, where the White Sands gypsum field lies, create a uniquely perfect environment for glistening-white dunes that visitors can hike and even sled on. The powdery white gypsum dunes look just like snow, and make for equally good sledding, with the added benefit (for people like me anyway, who prefer warmer climates) of desert temperatures. Just be sure to only sled in authorized areas to protect the area's delicate vegetation.

Speaking of desert heat, another benefit of the unique gypsum sand in this park? Unlike normal sand, gypsum doesn't absorb and retain the sun's heat, so the dunes are generally cool and comfortable to walk on even on the hottest days!

YELLOWSTONE

NATIONAL PARK

WYOMING, MONTANA, AND IDAHO ★ ESTABLISHED 1872

Yellowstone National Park is home to over ten thousand hot springs and geysers—much like the average kitchen, if this unimpressed visitor is to be believed.

Most people are familiar with Old Faithful or the colorful Grand Prismatic Spring (pictured left), but with 9,998-plus additional thermal features, Yellowstone is earth's largest active geyser field, created by the planet's largest volcano.

It's difficult to imagine being disappointed by the thermal features alone, but if that's not enough to appease a skeptical tourist, the park also boasts the largest concentration of mammals in the lower forty-eight states, ranging from bison and grizzly bears to coyotes, bighorn sheep, mountain lions, and wolverines.

I first visited this park with my family at age ten. It was one of the first national park experiences I can remember, and I left thinking parks were basically open-air zoos because of all the wildlife we saw—black bears feasting on wildflowers, elk wandering in the nearby town we stopped in for lunch, mule deer looking both ways before crossing the street, massive bison on just the other side of the Madison River, and

even the distant silhouette of a grizzly bear being pursued by some misguided visitors hoping to catch it on film. (Even at age ten, I knew this was far from advisable.)

The wonder of Yellowstone is difficult to capture in a single illustration or a brief description, though plenty of reviewers try. The park is so large it bleeds across three different states—Wyoming, Montana, and Idaho—and spans 3,500 square miles. It's nearly three Rhode Islands of wilderness!

It's the oldest national park in the United States, but its history goes far beyond that, with evidence suggesting human presence as far back as 11,000 years ago. In addition, at least twenty-six Native American tribes have ancestral connections to the land. The land is rich in resources and was used for hunting, fishing, and gathering plants and obsidian. Plus, the thermal features were often used for religious and medicinal purposes.

In addition to the many geothermal features, Yellowstone spans mountains, lakes, canyons, forests, and rivers—Yellowstone Lake is the largest high-elevation lake in all of North America! If you're still not convinced of the grandeur of this park, it even has its own "Grand Canyon." Grand Canyon of the Yellowstone (pictured right) is more than twenty miles long and one thousand feet deep and includes waterfalls and thermal features steaming from the canyon's walls.

Whether you want to take a scenic drive, explore thermal basins, watch wildlife, backpack through the wilderness, stay in a campground, or take a secluded hike, Yellowstone (probably) won't disappoint.

"WHERE DO YOU TURN OFF THE GEYSERS?"

With more than half of the world's geysers located in Yellowstone, they're one of the major draws to the park. Despite what some visitors reportedly think, there's no one behind the curtain! Old Faithful is so named because it famously (and naturally) erupts on a pretty reliable schedule, but other features are harder to predict. For those looking for a less famous but arguably more impressive geyser, check out Beehive, which erupts one to two times per day with heights of 130 to 190 feet.

SCENERY IS *distant*

AND *impersonal*

ZION

NATIONAL PARK

UTAH ★ ESTABLISHED 1919

Kind of sounds like this person is confusing Zion with their latest awkward dating-app date, to be honest.

Zion National Park, Utah's most visited national park, mainly revolves around Zion Canyon—fifteen miles long and almost three thousand feet deep in some places! While the canyon towers above you, it hardly feels distant or impersonal—even if you only have time to drive through on the Zion–Mount Carmel Highway, the views fill your entire visual field with both close-up and expansive displays of orange rock and lush green. And if you've got time to explore, you can see over ten thousand years of human history on display, up close and personal. Cliff dwellings and rock markings between 800 and 1,500 years old from the Anasazi, one of the original occupants of Zion Canyon, remain in the park today.

RANGER TIP: PLAN AHEAD AND EXPECT CROWDS

Zion is the busiest park for its size, and one of the busiest in general (it's one-fifth the size of Yosemite but matches it in annual visitors!), and also a short drive from many major urban areas. Because of this, many visitors are casual first-time parkgoers who arrive unaware of the rules and vastly underprepared for the reality of a national park. Most people visit Zion for the iconic, heavily 'grammed, and difficult Angels Landing or Narrows hikes, but there's much more to the park than these! While it can be difficult to escape the crowds at Zion without a backcountry trip, check out the Pa'rus Trail for a relatively uncrowded hike—it offers some of the best views at sunrise and sunset!

MIDWEST

The Midwest Region of the NPS covers Arkansas, Illinois, Indiana, Iowa, Kansas, Michigan, Minnesota, Missouri, Nebraska, North Dakota, Ohio, South Dakota, and Wisconsin. These thirteen states are home to approximately fifty-seven park units that represent the diverse natural and human history of the Midwest. As a native Midwesterner, I know this part of the country often has a reputation for being boring, but I think the parks here prove it's anything but! From lush, remote wilderness, to massive sand dunes, to wide-open plains teeming with wildlife, the Midwest is far from bland.

THEODORE
ROOSEVELT

North
Dakota

VOYAGEURS

Minnesota

ISLE
ROYALE

South Dakota

BADLANDS

Wisconsin

SLEEPING
BEAR DUNES

ND
AVE

Michigan

Iowa

Nebraska

INDIANA
DUNES

CUYAHOGA
VALLEY

Illinois

Ohio

Indiana

TALLGRASS
PRAIRIE

Kansas

Missouri

GATEWAY
ARCH

Arkansas

HOT SPRINGS

THE ONLY THING BAD ABOUT THESE LANDS

IS THE ENTIRE EXPERIENCE

BADLANDS

NATIONAL PARK

SOUTH DAKOTA ★ ESTABLISHED 1978

You know when you're SUPER angry about something and you come up with the best zinger later in the shower and just have to share it with people? That's this review.

Located in southwestern South Dakota, Badlands National Park is 244,000 acres of wilderness, full of pinnacles, buttes, and spires and the largest protected mixed-grass prairie in the United States. The Badlands are a wonderland of colorful formations, and driving through this bizarre and unique landscape as a kid left an indelible impression on me—it's one of the places that made me realize just how diverse and spectacular US geography can be.

It also has one of the world's richest fossil beds, giving scientists the opportunity to study the evolution of the horse, rhino, and saber-toothed cat. It's home to plenty of still-living wildlife too, though, from tiny shrews to two-thousand-pound bison, reptiles, amphibians, birds, and butterflies.

The Lakota gave the land its name, Mako Sica, meaning "land bad," because it was difficult to cross due to the rocky terrain, lack of water, and extreme temperatures. Today the Badlands are a not-so-bad place for hiking, fossil hunting, taking a scenic drive, and spotting wildlife, though the temperatures still get pretty extreme, peaking close to 90 degrees Fahrenheit in the summer!

"The Badlands grade all the way from those that are almost rolling in character to those that are so fantastically broken in form and so bizarre in color as to seem hardly properly to belong to this earth."

—THEODORE ROOSEVELT

CUYAHOGA VALLEY
NATIONAL PARK

OHIO ★ ESTABLISHED 2000

If you would just get rid of all this dirt on the trails, we wouldn't have this problem!

The winding Cuyahoga (a blend of a few native peoples' words for the area, typically translated to mean "Crooked River") is surrounded by 33,000 acres of deep forests, rolling hills, and open farmlands. The park was created to protect natural, historic, and recreational resources all in one place and increase tourism in the area, protecting local flora and fauna, preserving the remains of the Ohio & Erie Canal, and providing opportunities for recreation and solitude. A quiet refuge from nearby Cleveland and Akron, Cuyahoga offers a variety of activities, from hiking, golfing, kayaking, and historic train rides to snowshoeing and cross-country skiing during Ohio's winters.

RANGER TIP: MORE THAN JUST A STOPOVER

Many visitors treat Cuyahoga Valley as a stopover, and only make time for the short hikes at the main attractions like Brandywine Falls, Blue Hen Falls, and Beaver Marsh, but taking a little extra time can reveal some of the best features. Take the full Ledges loop, and it will take you past Ice Box Cave, which is home to bats and allows much closer inspection of the Ledges than simply visiting the overlook at sunset (although that's great too!). Beaver Marsh also has a lot to offer if you take your time. Morning and evening are best for wildlife, but sitting and taking in the views for a while will usually reveal quite a few birds, all sorts of aquatic life, and even elusive beavers, fox, or raccoons.

GATEWAY ARCH
NATIONAL PARK

MISSOURI ★ ESTABLISHED 2018

I mean, it IS a completely curved arch, so yeah—there are no point(s). File this one under "technically true."

Gateway Arch is the world's tallest arch, standing at 630 feet tall (fun fact—it may not look it, but it's exactly as wide as it is tall!), and to those of us who've lived in the St. Louis area, it's come to symbolize home. Gateway Arch is one of the few national parks that is more about preserving human history than places of natural or scenic significance. Most other parks like this are historical parks or memorials (and before it was elevated to a national park, Gateway Arch was the Jefferson National Expansion Me-morial). Overall, the park is a memorial to Thomas Jefferson's role in opening the West to the pioneers who helped shape its history, and to Dred Scott, who sued for his freedom in the Old Courthouse around the corner from the arch.

The Gateway Arch was designed in 1947 by Finnish American architect Eero Saarinen, who sadly died before he could see his vision come to life. The arch is widely considered a massive feat of engineering—many people didn't think it would stand, and if measurements had been even $\frac{1}{64}$th of an inch off, it wouldn't have, as they wouldn't have been able to connect the two legs at the top!

NO PRESIDENTS ALLOWED

As a claustrophobic former St. Louisan, I've visited but never been up in the arch, and I'm in distinguished company! The Secret Service has forbidden all presidents from going to the top due to security concerns. Given that it's a very tight, enclosed space, it would be difficult to maintain their safety.

DON'T WASTE YOUR TIME
UNLESS YOU'RE REALLY INTO

HOT SPRINGS

HOT SPRINGS
NATIONAL PARK

ARKANSAS ★ ESTABLISHED 1921

It appears Hot Springs National Park's only crime is honesty.

Speaking of crime, looking at the quaint town today, you'd never guess Hot Springs, Arkansas, was once a hotbed for gambling and Prohibition-era bootlegging. The secluded location and the legalization of gambling by Mayor Leo McLaughlin made it a popular hideout for Frank Costello, Bugs Moran, and other infamous mobsters. Al Capone frequented the area to strike deals with moonshiners, and eventually purchased a dairy outside of town and turned it into his own moonshine distillery. If you're a crime history junkie, you might want to check out the Gangster Museum of America in town when you're finished in the park.

Long before its mobster history, several Native American tribes called this area the Valley of the Vapors, and it was said to have been a neutral territory where all would enjoy its healing waters. This park is the oldest area managed by the National Park Service, first protected as Hot Springs Reservation in 1832—which means it predated Yellowstone National Park by forty years and Yosemite's original protection as a state park by thirty-two years!

Hot Springs National Park is a mixture of man-made and natural resources, preserving historic bathhouses built on top of natural hot springs, as well as the surrounding lands. Today you can still soak in the thermal waters in historic Bathhouse Row, a row of eight bathhouse buildings constructed between 1892 and 1923. (The bathhouses are the only place you can soak in the hot springs—there are no longer any outdoor thermal springs available for soaking.) Water from the hot springs is also pumped into several downtown hotels and spas. The water is even available at public fountains! So yeah, definitely go here only if you're at least somewhat interested in hot springs.

DUNES ARE
NOT THAT HIGH

INDIANA DUNES

NATIONAL PARK

Given how flat most of northern Indiana is, I'm not really sure how high you could expect dunes on a beach there to be? The dunes literally swallowed a child once (don't worry, he's OK!), so I'm personally not going to underestimate them.

Not all national parks are about preserving the largest, tallest, deepest, or otherwise superlative natural wonders. Some, like Indiana Dunes, are about the ecological significance of the area, and protecting delicate and important habitats and ecosystems.

Indiana Dunes is known as the birthplace of ecology, and despite its relatively smaller size, it's the fourth most biodiverse national park! There are more plant and animal species here than all of Hawaii. Over 1,100 flowering plant species call the area home, and the park protects over 15,000 acres of ecosystems varying from dunes to swamps, oak savannas, marshes, bogs, prairies, rivers, and forests. So needless to say, there's plenty to explore here even if the dunes don't strike you as notably tall. (They may not be the tallest out there, but they're double what we have here in North Carolina, so I'm personally still impressed!)

While most people probably think of summer activities for a beach-based park, Indiana Dunes thrives in all seasons. Beyond the obvious summer activities, spring wildflowers pop up along the Little Calumet River from April to May, and fall foliage peaks around mid-October. With all the plant and animal species, it should be no surprise that Indiana Dunes is a great place for bird watchers, especially during spring and fall migrations. Each May, the Indiana Audubon Society hosts the annual Indiana Dunes Birding Festival, a four-day event showcasing the migratory birds in the Indiana Dunes area, including the national park. Along the Great Marsh Trail, keep an eye out for tree swallows, warblers, kingfishers, red-winged blackbirds, egrets, and herons. If you're more into identifying plants than animals, check out the Cowles Bog Trail—this part of the park is a national natural landmark due to its amazing plant diversity.

In the winter, you can cross-country ski or snowshoe across the dunes, stroll along the beach with much lighter crowds, and watch

the movements of the shelf ice on Lake Michigan. During cold winters, shelf ice mimics the landscape of the Arctic. Shelf ice is created when waves crash into floating ice collecting along the shore and then refreezes—it's not attached to the bottom of the lake but to the shore! There are several places to view the shelf ice within the park, but the best spot is said to be at West Beach on the Dune Succession Trail. Wherever you go, watch it from a safe distance and never try to walk on it!

Whether you fancy scouting for rare species of birds; hiking through dunes, wetlands, prairies, and forests; biking on the Calumet Bike Trail; lounging on a sandy beach; taking a dip in Lake Michigan; or cross-country skiing or snowshoeing, there's plenty to do year-round, and you'll find a pleasant activity no matter when you visit.

LISTEN TO THE SINGING SANDS

The sand that builds up to form the dunes in Indiana Dunes is made out of quartz and silica, left behind by receding glaciers thousands of years ago. This quartz and silica composition often creates a reverberating sound when you walk across it, though it's not completely understood why this happens! The phenomenon has come to be known as "singing sands."

ISLE ROYALE
NATIONAL PARK

MICHIGAN ★ ESTABLISHED 1940

This is a fair point. I mean, who goes to a remote island park to unplug?

Located on the largest freshwater lake in the world, Lake Superior, Isle Royale is a woodsy waterside haven for adventures for backpackers, hikers, kayakers, canoeists, other boaters, and even scuba divers. Off the coast of Michigan's Upper Peninsula, Isle Royale is one of a few national parks that is not accessible by driving—you have to get there by ferry, private watercraft, or seaplane, which explains why it's one of the least visited national parks! It can be tough to get to, but once you arrive, you won't want to leave.

The average national park visit is only about half a day (which seems way too short to truly experience *any* park, if you ask me!), but the average visitor to Isle Royale stays for four days—the longest average visit of all of the national parks. Meanwhile, the average visitor spends *an hour* in Saguaro

National Park (I guess most people don't like cacti), *two hours* in the National Park of American Samoa (after that flight?!), and *seven hours* in Rocky Mountain National Park (I could easily spend a week there and not feel "done"). Per NPS statistics from 2019, only twelve parks keep the average visitor occupied for more than a day (more than twelve "recreation hours")—from shortest to longest: Mount Rainier, Glacier Bay, Channel Islands, Yosemite, Grand Canyon, North Cascades, Yellowstone, Big Bend, Sequoia, Kings Canyon, Wrangell–St. Elias, and, finally, Isle Royale.

If you spend a few days in this remote North Woods wilderness, you'll find waterfalls, wildlife, 166 miles of hiking trails, over 450 small islands to explore, and wide-open spaces for solitude and reflection. But it is true that you probably won't find much of a cell signal (and probably not many other people!).

NOT MUCH TO DO

SLEEPING BEAR DUNES
NATIONAL LAKESHORE

MICHIGAN ★ ESTABLISHED 1970

Sleeping Bear Dunes is the largest freshwater dune system in the world, with dunes towering as high as 450 feet. Between the options to drive, hike, camp, canoe, or swim, I find it hard to believe you wouldn't be able to find *something* to do here. (In a place like this, even nothing counts as something in my book!)

Along the shores of Lake Michigan, Sleeping Bear Dunes National Lakeshore is full of massive sand dunes that give you an incredible view of the lake, along with lush forests, unique plants, and wildlife, including, yes, bears! Though that isn't where the park gets its name. The park is named for Mother Bear, a dune that once resembled a sleeping bear.

The native Anishinaabe people used the Mother Bear dune as a navigational landmark and have a legend about how she came to be: Long ago, a mother bear and her two cubs were driven to Lake Michigan by a forest fire. The bears swam for hours, but the cubs were tired. Mother Bear reached the shore first and climbed to the top of a bluff to watch out for her cubs, but the cubs drowned just within sight of the shore. The Great Spirit created two small islands (the North and South Manitou Islands) to honor the cubs, and a solitary dune, Mother Bear, to represent the faithful mother bear, waiting for her cubs.

RANGER TIP: AS WITH MANY PARKS, GO EARLY TO AVOID CROWDS!

The Dune Climb and the Pierce Stocking Scenic Drive are some of the most visited parts of the park, so expect crowds and potentially some difficulty finding a parking spot. Come earlier in the morning when it's less crowded, maybe even early enough to take in a sunrise on the lake! The view from the lighthouse on South Manitou Island can't be beat and is just a ferry ride away—spend the day there for a fun, family-friendly adventure.

TALLGRASS PRAIRIE

NATIONAL PRESERVE

KANSAS ★ ESTABLISHED 1996

Once again, Tallgrass Prairie's only crime appears to be honesty. It's in the name, people!

Tallgrass Prairie National Preserve protects some of the last remaining tallgrass prairie in the United States. Tallgrass Prairie once covered 170 million acres of North America, but within a generation of settlers coming to the area, most of it had been transformed into farmland. Today less than 4 percent remains intact, and it's one of the rarest and most endangered ecosystems in the world.

Looking out at the expansive fields, you might think it's just some tall grass. While forty-plus species of grasses do make up about 80 percent of the ecosystem, Tallgrass Prairie is actually much more diverse than it sounds. The preserve is home to over 500 species of plants, 150 species of birds, 39 different reptiles and amphibians, and 31 different mammals. But you'll need to get out of the car to really experience it. Many of these plants and animals are much too small to see on a passing scenic drive!

"Nothing could be more lonely and nothing more beautiful than the view at nightfall across the prairies to these huge hill masses, when the lengthening shadows had at last merged into one and the faint afterglow of the red sunset filled the west."

—THEODORE ROOSEVELT

THEODORE ROOSEVELT

NATIONAL PARK

NORTH DAKOTA ★ ESTABLISHED 1978

The possibility of seeing bison and wild horses—and the definite presence of badlands—is more than enough attraction for me!

Theodore Roosevelt National Park is the only US national park named after a person—America's twenty-sixth president, who is often called the conservation president. The park honors Roosevelt, who lived as a rancher in the Dakota Territory in the 1880s and went on as president to conserve 230 million acres of public land for future generations. Theodore Roosevelt came to the Dakota Territory to hunt bison in 1883, and many credit the landscape and lifestyle he experienced in this region as what led to his desire to conserve and protect many of the areas we love today.

The formations in the park are composed of layers of many kinds of rock, including coal. In one area of the park, there was a twelve-foot-thick coal vein that caught fire in 1951 and burned for twenty-six years. (Yes, you read that right, although my mind still doesn't fully comprehend this!) In the areas where it was exposed from underground, visitors could see flames, embers, and smoke, and some even roasted marshmallows over the fire, which finally burned out in 1977.

RANGER TIP: OH, GIVE ME A HOME, WHERE THE BUFFALO ROAM . . .

The song really means it when they talk about buffalo roaming. The bison (I know, I know, bison and buffalo are not the same) in Theodore Roosevelt are wild animals, free to go wherever they please in the park (including on the roads). You can ask a ranger where they've recently been seen, but no guarantees they'll still be there by the time you arrive. Embrace the unpredictability of nature and enjoy the scenery, with or without a bison in view.

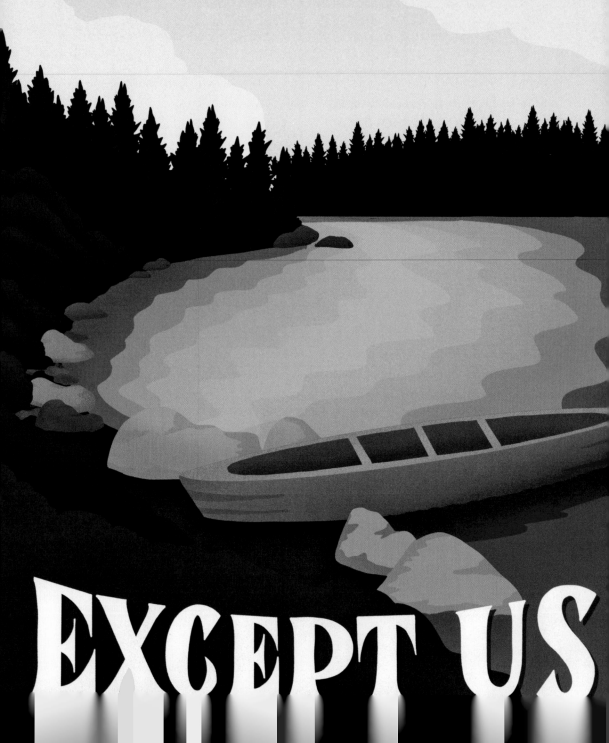

VOYAGEURS
NATIONAL PARK

MINNESOTA ★ ESTABLISHED 1975

I know I, for one, can't stand it when I have a majestic piece of nature all to myself (and yes, this was actually a complaint!).

Voyageurs National Park comprises 218,000 acres of more than thirty lakes and nine hundred islands stretching along the US–Canada border. A third of the park is water, so the park is accessible only by boat (or snowmobile in the winter).

The park is named for French-Canadian voyageurs (meaning "traveler"), who paddled canoes through the area for fur trading in the 1700s. The voyageurs were famous for their paddling stamina, often out on the water for up to sixteen hours a day. When you visit Voyageurs, you'll understand why they needed it!

If you don't own a boat to explore Voyageurs with, there are options to privately rent canoes, kayaks, stand-up paddleboards, fishing boats, and other water vessels. Or you can take a boat tour with a park ranger. Once you're on land, there are more than twenty-seven miles of scenic trails to explore. Keep an eye out for ancient petroglyphs—the first evidence of human inhabitants goes back over ten thousand years, and the Chippewa (also called the Ojibwe) people lived on the land at least as far back as the 1700s—over 220 archeological sites have been documented within the park.

HEADING TO CANADA, EH?

Paddling through the maze of waterways among the islands, you can unwittingly cross the Canadian border. Be sure to take a map or GPS system that includes accurate navigational markers. And maybe your passport, just in case!

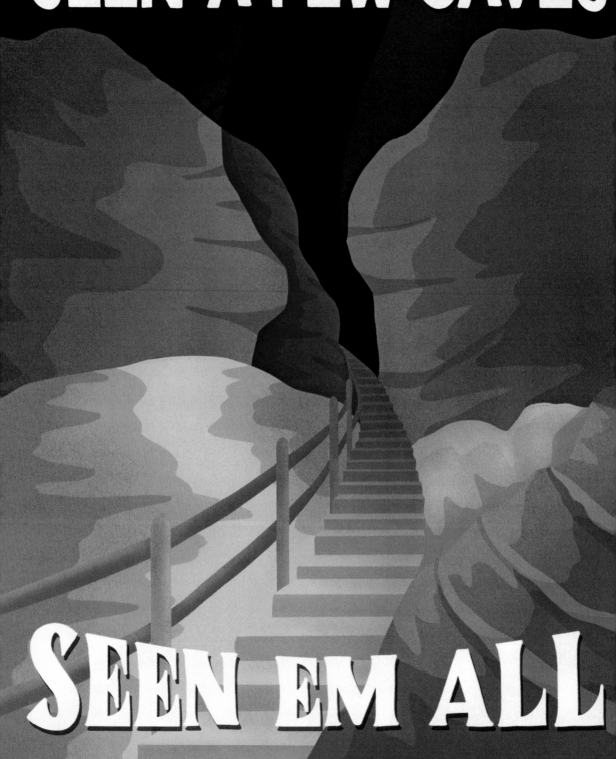

WIND CAVE
NATIONAL PARK

Just one of the longest cave systems in the world, with so much crazy texture (hello, boxwork!) it's basically impossible to capture in an illustration. And on top of that (literally), one of the few remaining mixed-grass prairies in the United States. Same old, same old.

One of the most complex maze caves in the world, Wind Cave was the first cave to be designated as a national park. Wind Cave is named for the rushing winds that move in and out of its entrances, but boxwork is what makes Wind Cave so unique. Boxwork is a rare formation on the ceiling of the cave, made of thin calcite fins that look kind of like a wonky honeycomb. At least 95 percent of the world's known boxwork is found in Wind Cave, so you've almost certainly never seen a cave like this before.

But even if you have, Wind Cave National Park preserves more than just its namesake cave system. There are two very different

FUN FACT:
Boxwork is a formation that juts out from cave walls or ceilings and is made of thin blades of calcite that create a box-like, honeycomb pattern.

worlds within one park here, as it also protects the unique mixed-grass prairie habitat above the caves, one of the few remaining in the United States. The mixed-grass prairie is home to native wildlife like bison, elk, pronghorn, mule deer, coyotes, prairie dogs, and the once almost-extinct black-footed ferret.

The caves can be slippery, so make sure to wear good walking shoes, and bring layers! The cave temperature is always 53 degrees Fahrenheit, even on the hottest summer days. And come early—tickets for cave tours are first come, first served, and during peak visit times they fill up for the day early.

BREATHING EARTH: THE LAKOTA EMERGENCE STORY

The land within Wind Cave National Park has historical, cultural, and spiritual meanings to many Native Nations, and the park currently consults with twenty tribal governments on major projects. To many of the Lakota people, Wind Cave is the sacred site in their creation story. When no people or bison were living on Earth yet, people lived underground in the Tunkan Tipi (spirit lodge), and were waiting for Earth to be ready to them. To get to the spirit lodge, you had to travel through a passageway, which modern Lakota call Maka Oniye, meaning "breathing earth"—also known as Wind Cave. Before Earth was ready, a group of people disobeyed the Creator and went to the surface. As punishment, they were transformed into the first bison. When Earth was finally ready for people, the Creator instructed them to follow the bison, which would give them everything they needed to survive. Once the people left the cave, the Creator shrank the opening down to the size it is now—too small for most people to enter—to serve as a reminder to the people of where they'd come from.

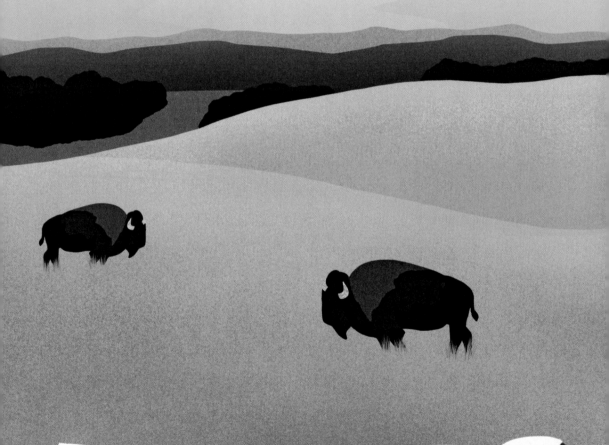

NORTHEAST
⅗ NATIONAL CAPITAL

The Northeast and National Capital Regions of the National Park Service protect many sacred places in US history, in addition to gorgeous natural scenery and places of Native American cultural significance. Larger-than-life monuments to some of the United States' most important historical figures, some of the oldest mountains in the world, and stunning Atlantic coastlines are just a few of the incredible places sure to leave some people completely underwhelmed.

Maine

ACADIA

Vermont

New Hampshire

New York

Massachusetts

Connecticut

CAPE COD

Rhode Island

STATUE OF LIBERTY

New Jersey

Pennsylvania

Maryland

Delaware

HARPERS FERRY

LINCOLN MEMORIAL

ROCK CREEK

ASSATEAGUE ISLAND

West Virginia

SHENANDOAH

Washington, DC

NEW RIVER GORGE

Virginia

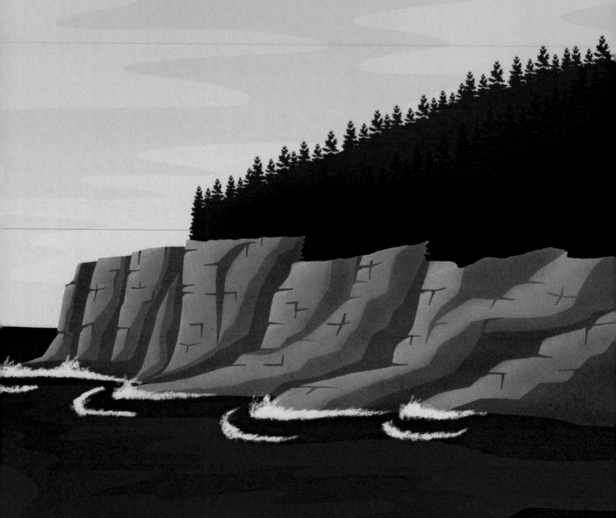

ACADIA
NATIONAL PARK

While I'm not sure what kind of resolution you'd expect from a complaint like this, this review isn't wrong. If there's one thing the Atlantic Ocean is known for, it's decidedly *not* for being warm.

The coast of Acadia is no exception, with average water temperatures peaking at about 60 degrees Fahrenheit in the summer. While it may not be great for most casual swimmers, luckily Acadia has a lot more to offer.

With mountain vistas, scenic drives, hiking trails for all skill levels, and rocky coastlines, it's no wonder Acadia, which was the first national park east of the Mississippi River, is often called the crown jewel of the North Atlantic Coast.

Although Acadia is one of the smaller national parks based on land size, it's one of the most visited! Famous for its fall foliage, stunning coastline cliffs, and Cadillac Mountain, the tallest mountain on the Atlantic Coast of the United States, it attracts over 3.4 million visitors each year—presumably only a few of whom leave disappointed. Despite the cold temperatures, Acadia is also a sight to behold in the winter, covered in a blanket of white and with far fewer crowds.

Another incredible feature of Acadia is Thunder Hole, a chasm in the cliffside where waves crash against the rocks, often creating a thunderous sound. The water can spray forty feet in the air at times, so keep this review in mind and dress to stay dry and warm. About two hours before high tide is said to be the best time to visit. As with all natural phenomena in the parks, no, there's no button for rangers to press to make Thunder Hole go boom.

Aside from the stunning natural features, Acadia is also home to three lighthouses, including the often-photographed Bass Harbor lighthouse (pictured on the previous page). Built in 1858, the lighthouse sits up on a rugged, rocky shoreline, creating a classic New England view the coastline would feel incomplete without.

BE THE FIRST PERSON TO SEE THE SUNRISE IN THE UNITED STATES

Are you a morning person? If so, check out sunrise from Cadillac Mountain (pictured right)! From October 7 to March 6, it's the first place to see the sunrise in the United States, and a stunning one at that. As of 2020, you now need reservations, so plan ahead!

HORSE POOP

ON THE BEACH

ASSATEAGUE ISLAND

NATICONAL SEASHORE

MARYLAND AND VIRGINIA ★ ESTABLISHED 1965

As the old saying goes . . . if you want to see wild horses, you're going to have to deal with a bit of horse poop.

Assateague Island is best known for its wild horses. Local legend claims they are descendants of horses that survived a shipwreck. In actuality, local residents deliberately kept horses confined on the island because of the taxes imposed on fences on the mainland. The wild horses on Assateague are actually feral, not wild—they're descendants of those domestic horses that have gone back to a wild state.

Due to their salty diet of beach grass and cordgrass, they're smaller than most horses and are closer in size to ponies. But their short stature won't stop them from defending themselves against visitors who get too close—stay at least forty feet away to keep yourself (and the horses) safe!

If horses aren't your thing, Assateague also offers bird watching, hiking trails, open beach, biking, and camping. For a less-frequented recreational option, try a paddling activity on the bayside rather than in the ocean. You'll get farther away from the crowds and see a (literal) different side of the island. No matter what you do, watch your step on land—I hear those wild horses don't clean up after themselves!

Assateague Island is one of ten national seashores, a designation first given in 1953 to Cape Hatteras in North Carolina. The goal of national seashores along the Atlantic, Pacific, and Gulf Coasts is to preserve the shoreline, prevent overdevelopment, protect wildlife, and maintain areas for public enjoyment and recreational use.

"The world is not to be put in order. The world is order. It is for us to put ourselves in unison with this order."

—HENRY MILLER

THERE ARE
SHARKS HERE

CAPE COD

NATIONAL SEASHORE

▶ MASSACHUSETTS ★ ESTABLISHED 1961 ◀

Cape Cod National Seashore is home to a wide variety of land and sea life, including the occasional shark, to one visitor's immense displeasure.

Wildlife is a feature (or a hazard, depending on your perspective) of just about every national park, and seashores are no exception! Cape Cod National Seashore offers a refuge for turtles, seals, snakes, piping plovers, and thirty-two species that are rare or endangered in Massachusetts.

If a shark prevents you from taking a swim in Cape Cod, there's still plenty else to explore. With over forty miles of beaches, plus marshes, ponds, and wild cranberry bogs, there is a boatload (pun intended) of activities to keep you busy.

With almost 44,000 acres of protected ponds, woods, and beachfront, Cape Cod offers opportunities to hike, kayak, canoe, snorkel, swim, bike, lounge on a pristine beach, or explore lighthouses. It's worth a visit, even if there is pesky wildlife to contend with.

If the natural sites don't grab you, there's plenty of culture and history to take in, too. Cape Cod is only about 18,000 years old geographically, and humans have occupied the land for at least 10,000 of those years. The area is part of the ancestral homeland of the Mashpee Wampanoag and Wampanoag Tribe of Gay Head (Aquinnah) people, who were nearly wiped out by diseases brought by European settlers. Despite their encounters with settlers, the tribe survived and continue to occupy the same coastline as their ancestors today—to learn more about the Wampanoag culture and history, stop by the Mashpee Wampanoag Museum on the way back inland from Cape Cod.

Nauset Light, a restored lighthouse on Cape Cod

HARPERS FERRY

NATIONAL HISTORICAL PARK

▶ WEST VIRGINIA, VIRGINIA, AND MARYLAND ★ ESTABLISHED 1963 ◀

Nestled at the confluence of the Shenandoah and Potomac Rivers is a quaint, historic letdown known as Harpers Ferry National Historical Park.

The park preserves Harpers Ferry, a historic and picturesque town in the Blue Ridge Mountains where pioneers, inventors, soldiers, townspeople, teachers, and civil rights leaders made their mark on US history. Harpers Ferry is significant not because of a single person or event but because of *several* important moments, all of which greatly influenced US history.

It was a stop on the Baltimore & Ohio Railroad, the first successful American railroad; the location of Storer College, one of the earliest integrated schools in the United States; and the site of the first public meeting of W. E. B. Du Bois's Niagara Movement, a civil rights group dedicated to securing social and political change for Black Americans. It also was one of the armories where there was the first successful application of interchangeable parts.

Perhaps most famously, Harpers Ferry was the location of John Brown's raid. Brown, an abolitionist, led a group in a raid of the federal armory in Harpers Ferry in 1859, in the hopes of starting a revolt of enslaved people and abolishing the institution of slavery. A total of sixteen people died in the ensuing clashes, including ten of Brown's eighteen men. Brown was later tried for treason and executed. Though the raid failed, it's now clear it was an important turning point toward the Civil War and the eventual end of slavery in America. Suffice it to say, this park has more than its fair share of history to explore, so it's hard to imagine being let down by a visit.

> **"I have only a short time to live, only one death to die, and I will die fighting for this cause. There will be no peace in this land until slavery is done for."**
>
> **—JOHN BROWN**

NOT AS COOL AS

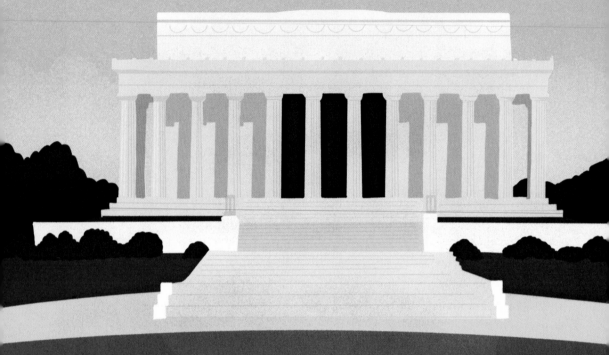

I THOUGHT

LINCOLN

MEMORIAL

After seeing the larger-than-life statue of Lincoln, I'm not sure how much cooler you could expect it to be, but maybe this person missed a few of the more interesting details.

Like many memorials and statues, the Lincoln Memorial is full of symbolism and thoughtful details to honor Abraham Lincoln's legacy. Architect Henry Bacon modeled the building after the Parthenon in Greece, because he thought it was only appropriate that a memorial for a man who defended democracy reflect the birthplace of democracy itself. Most people think what's under Lincoln's arms are books, but in fact, it's a Roman symbol of power: a bundle of rods bound by a leather strap, known as fasces. There are thirteen rods, which represent the thirteen original states, and that together, we are stronger. ("E Pluribus Unum" is our motto, after all!) This was such an important symbol to the project that you can actually find it outside as well, carved in the base of the stairs before you walk up, setting the tone for the entire memorial.

There is one rumored piece of symbolism that isn't there, though. Apparently, an often-told legend is that Robert E. Lee's profile is carved into the back of Lincoln's head, but it's just waves and tufts of Lincoln's hair back there!

A TYPO SET IN STONE

The north wall of the monument has an inscription of Abraham Lincoln's second inaugural address, delivered at the end of the Civil War. At the end of the first paragraph of his speech, Lincoln said, "With high hope for the future, no prediction in regard to it is ventured," but the inscription has an oopsie: the word "FUTURE" is miscarved as "EUTURE," which you can still see despite attempts to fill it back in. Maybe this is a carving superstition, like when knitters and crocheters intentionally drop a stitch?

MIST OBSCURED

THE VIEWS

NEW RIVER GORGE

NATIONAL PARK

As a frequent visitor to the Appalachian mountains, I've come to think of mist and fog as a part of the viewing experience, but I guess this person would disagree with me.

As of 2020, "the New" is America's NEWest national park, after thirty-plus years as one of five national rivers (plenty of time to already have had some disgruntled visitors). The new designation, an effort to emphasize outdoor recreation as tourism in West Virginia, won't change much other than elevating the visibility of this park—the area that is now a national park won't allow hunting, while the area that's now a national preserve still will. The irony is that the not-so-New River Gorge is actually one of the continent's oldest rivers. This 73,000-acre stretch of rugged canyon is known as a world-class rock-climbing and paddling destination, but there's plenty else to do if you're not a climbing enthusiast. The park is full of opportunities for whitewater rafting, peaceful floating, hiking, fishing, and more!

Aside from the incredible natural beauty, the area is also known for the New River Gorge Bridge, which took 22,000 tons of structural steel and spans the 3,030-foot-wide gorge. It towers 876 feet above the river, and to commemorate the bridge's completion, Bridge Day is held the third Saturday of every October, closing traffic so pedestrians can explore the bridge. BASE jumpers are also allowed to jump for a few hours that day. Given my immense fear of heights, this whole day gets a hard pass from me!

ROCK CREEK
PARK

Rock Creek Park is a 1,754-acre oasis of nature within the bustling US capital, and as the oldest natural urban park in the National Park System, it's been seriously unimpressive since 1890.

Rock Creek Park was the third national park to be designated by the federal government, following Yellowstone and the former Mackinac National Park (which was turned back over to the state of Michigan in 1895, when the fort on the island was decommissioned). It's more than twice the size of Central Park in New York City, which is impressive in and of itself given Washington, DC's relative size.

Having lived in DC for five years, I can confidently say that this park is impressive indeed. Most of my fondest memories of living there involve spending time in Rock Creek, and it's where I'd often go to relax and get inspired when I first started hand-lettering and illustrating. While it's no Yosemite or Yellowstone, it's one of the best city parks I've ever been in.

Whether you want to run or bike on the multiuse trails, find a secluded spot for a picnic, or go for a hike and forget you're in the city, Rock Creek Park does the job.

"No matter how perfect the scenery of the park may be or may become, no matter how high its potential value, that value remains potential except insofar as it is enjoyed by large and ever larger numbers of people, poor and rich alike."

—THE OLMSTED BROTHERS, ARCHITECTS OF ROCK CREEK PARK

SHENANDOAH
NATIONAL PARK

VIRGINIA ★ ESTABLISHED 1935

Apparently this visitor missed the memo about one of Shenandoah National Park's most famous attractions: Skyline Drive, a 105-mile scenic drive with nearly seventy overlooks, which can easily occupy an entire day.

For those who are interested in hiking, Shenandoah does have a lot to offer. There are over five hundred miles of trails to choose from, ranging from quick day hikes to multiday backpacking trips, including 101 miles of the Appalachian Trail. With waterfalls, long-range views, and wildlife galore, Shenandoah is great in any season, whether you come to see wildflowers in the spring or stunning displays of red, orange, and yellow leaves in the fall.

Shenandoah is a unique park in that it wasn't wilderness set aside to be preserved. Somewhat controversially, it was created through eminent domain to allow lands that had been heavily used by farmers, loggers, miners, and trappers to regenerate. In 1935, much of the land was open space, but forest has now reclaimed 95 percent of the park.

RANGER TIP:
VISIT THE SOUTHERN END FOR FEWER CROWDS!

Many of the visitors to Shenandoah come from the DC area, since it's only about seventy miles away from the city. (As a former DCer, I can confirm this!) If you look at a map of the area, that means most people are getting to the park at the north end or in the middle. So if you're looking for a bit more seclusion, check out the southern end! It's generally much quieter, and you probably won't see that many people on trail.

STATUE OF LIBERTY
NATIONAL MONUMENT

NEW YORK ★ ESTABLISHED 1924

Liberty Enlightening the World was a gift of friendship from the people of France to the United States and is universally recognized as a symbol of freedom and democracy around the world. But technically, I guess, it's also a green statue.

Designed by Frédéric Bartholdi and dedicated on October 28, 1886 (and later designated a national monument in 1924), the statue has come to symbolize freedom for immigrants—nearly twelve million people passed through neighboring Ellis Island. The design of the statue features a lot of symbolism: the halo of seven spikes around her crown represents the world's seven seas and continents; the tablet, inscribed with "July 4, 1776" in Roman numerals, represents American independence; to symbolize the abolition of slavery, Bartholdi placed a broken shackle and chains at the statue's foot.

WHY IS THE STATUE GREEN?

The exterior copper covering of the Statue of Liberty is $3/32$ inches (2.4 millimeters) thick, a little thinner than two US pennies put together. When it was first installed, the statue was the color of a penny—it took twenty years for the copper to patina to the blue-green color we all instantly recognize today. The patina builds up on top of the copper, and it's often as thick as the copper behind it. It provides a natural layer of protection to keep the copper from wearing away.

SOUTHEAST

The NPS Southeast Region spans nine states—Kentucky, Tennessee, North Carolina, South Carolina, Georgia, Alabama, Mississippi, Louisiana, and Florida—plus Puerto Rico and the US Virgin Islands. From parks that are almost entirely underwater to some of the oldest mountains in the world, the Southeast is a region full of lush landscapes teeming with wildlife and plant life. It's home to some of the most visited attractions in the National Park System (Great Smoky Mountains National Park and the Blue Ridge Parkway, to start), but that just means there are more visitors who leave unsatisfied, apparently!

MAMMOTH CAVE

Kentucky

GREAT SMOKY
MOUNTAINS

BLUE RIDGE
● PARKWAY

Tennessee

North Carolina

CAPE
HATTERAS

South
Carolina

CONGAREE

Georgia

Alabama

Florida

DRY TORTUGAS

EVERGLADES

BISCAYNE

VIRGIN
ISLANDS

BISCAYNE

NATIONAL PARK

FLORIDA ⭐ ESTABLISHED 1980

I'd personally consider it a plus if I could explore coral reefs and shipwrecks and see dolphins, turtles, and tons of fish at Biscayne National Park without interruption. Maybe the park's trying to tell you something.

Biscayne National Park, which is over 90 percent water, preserves Biscayne Bay, one of the top scuba diving areas in the United States. Over six hundred species of native fish live along one of the world's largest coral reefs, and you'll have the chance to see stingrays, jellyfish, crabs, iguanas, and bottlenose dolphins (if you're lucky)! The subtropical climate means there's typically sunshine at least three hundred days a year, so make sure to bring your sunscreen. But there's rarely cell service in the park, so probably leave your phone in the car (especially if it's not waterproof).

While Biscayne National Park was established primarily to protect the area's natural features, it also preserves ten thousand years of human history. Nearly every island in the park has evidence of use by native peoples. When European explorers arrived in the area, diseases like smallpox and measles swept through the native Glades and Tequesta populations and wiped nearly all of them out.

Below the water's surface are the remains of many shipwrecks. The park's Maritime Heritage Trail, which is a scuba diving or snorkeling trail, offers the chance to explore the remains of six shipwrecks spanning nearly a century. The oldest shipwreck on the trail, the *Arratoon Apcar*, sank in 1878 after running aground on a reef that had already claimed many other ships. The ship came to a halt just two hundred yards from where workers were actively building the Fowey Rocks Lighthouse, which was completed later that same year, highlighting just how important that lighthouse would be for preventing future shipwrecks.

"Everything in nature invites us constantly to be what we are."

—GRETEL EHRLICH

BLUE RIDGE
PARKWAY

Given that the parkway is 469 miles long, I think the fact that it goes on for a long time is . . . kind of the point?

The Blue Ridge Parkway stretches from the Great Smoky Mountains all the way to Shenandoah National Park, providing beautiful views year-round, offering the change to view wildflowers and trees in bloom in the spring, lush greenery in the summer, brilliant foliage in the fall, and expansive views in the winter.

I've driven various stretches of the parkway myself many times, and I can confirm it seems to go on forever—but that's OK, because I never wanted it to end anyway! There are tons of beautiful scenic overlooks, as well as quick access to many hiking trails, visitor facilities, and campgrounds. Depending on when you go, you can expect a lot of traffic on the parkway, particularly as visitors flock to see the famous fall foliage, and the rhododendron blooms that blanket the hillsides in the spring. But if you have the right mindset, the traffic is simply a built-in excuse to slow down and enjoy the layered, long-range views of the hazy blue mountains sprawling out endlessly before you.

FINAL LINK OF THE PARKWAY

The Linn Cove Viaduct, a seven-mile section of the Blue Ridge Parkway—the last piece of the parkway completed—was finished in 1987. Widely recognized as an engineering marvel, construction was delayed for over twenty years as environmentalists, landowners, engineers, and architects worked toward a design that would preserve and protect the fragile habitat. The instantly recognizable bridge hugs the face of Grandfather Mountain without damaging the landscape. It's so impressive, the American Society of Civil Engineers designated it a National Civil Engineering Landmark!

CAPE HATTERAS
NATIONAL SEASHORE

▶ NORTH CAROLINA ★ ESTABLISHED 1953 ◀

If you're looking for somewhere special to visit, keep looking. I guess the first-ever national seashore, which includes a massive lighthouse that was moved in one piece, just ain't gonna cut it.

Cape Hatteras was the first-ever designated national seashore, covering seventy miles of shoreline and protecting some of North Carolina's barrier islands. The seashore is home to many shorebird nests and five species of sea turtles, as well as to the tallest and most recognizable lighthouse in the United States, which warns ships away from the dangerous Diamond Shoals, a treacherous underwater current responsible for more than six hundred shipwrecks, giving Cape Hatteras the nickname the "Graveyard of the Atlantic."

Between camping, fishing, kayaking, enjoying an evening beach fire, or coming back at night to see the Milky Way in the sky *and* bioluminescent plankton in the water, there are so many activities to do that I suppose you could say there's no *one* special thing about it (although I doubt that's what the reviewer meant).

FUN FACT:
The remains of the *Laura A. Barnes*, a four-masted schooner that wrecked on the shore, were relocated to Coquina Beach for public viewing.

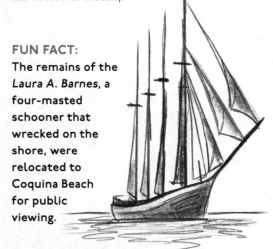

THE BIG MOVE

The iconic lighthouse that adorns the shores of Cape Hatteras is probably most famous for needing to be moved! Because of shoreline erosion, in 1999, the Cape Hatteras Light Station was relocated 2,900 feet from the spot on which it had stood since 1870. After a year of preparation, it took twenty-three days to move the lighthouse via hydraulic jacks, which pushed the lighthouse five feet at a time.

CONGAREE
NATIONAL PARK

SOUTH CAROLINA ★ ESTABLISHED 2003

Blaming a park in the Deep South for being hot and humid is right up there with blaming Glacier National Park for being too cold. Climate's gonna climate!

I spent a lot of my childhood living just an hour from Congaree (not to brag, but I visited it *before* it was a national park), and currently live only a few hours away, and I can confirm, it's frequently very hot and humid down here! The South is in a humid subtropical climate, after all. But I promise, it's also well worth a visit—but maybe just save it for the spring or fall, when it'll be a bit milder.

Known for giant hardwoods and towering pine trees, Congaree is a great place for a leisurely stroll on the boardwalk, a longer trek into more remote areas, or a canoe trip. It's a sanctuary for thousands of species of plants and animals, but it has also been a sanctuary to people. The native Santee, Catawba, and Congaree tribes inhabited the area until they were forced out by European settlers, and later on, enslaved people seeking freedom found refuge in the dense forests of the park, where it would be difficult to find them. They established small communities known as "maroons," where they could fish and hunt along the creek.

> "It is not so much for its beauty that the forest makes a claim upon men's hearts, as for that subtle something, that quality of air that emanation from old trees, that so wonderfully changes and renews a weary spirit."
>
> —ROBERT LOUIS STEVENSON

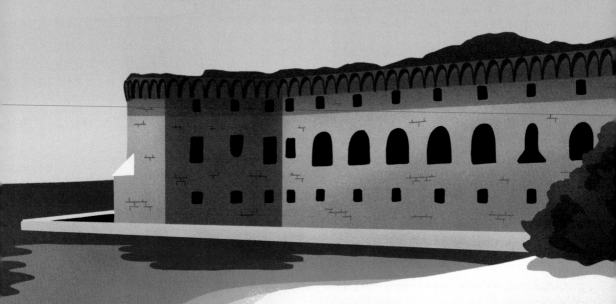

DRY TORTUGAS

NATIONAL PARK

Most of us call this exploring (and I'd be more than happy to just walk around this remote island and historic fort). But if walking around isn't your thing, given that it is an island, you could also lounge on the beach, snorkel, kayak, swim, scuba . . .

Dry Tortugas National Park is one of the smallest national parks if you measure by land area—but there's a lot to explore in the water too. Despite its deceptive name, this one-hundred-square-mile park *is* mostly water, after all. You'll have to get on a boat or plane to get to this remote island in the Gulf of Mexico, about seventy miles west of Key West. But once you're there, you'll be greeted by Fort Jefferson, white sandy beaches, picturesque blue waters, incredible coral reefs full of marine life, and a huge assortment of bird species. You can swim, snorkel, scuba dive, camp, and hike your way around the remote ocean wilderness.

The name *Dry Tortugas* comes from two places. In the summer of 1513, Juan Ponce de León named the cluster of keys Las Tortugas because of the abundance of sea turtles he'd caught while visiting (there are five different kinds of turtles in the park). Later, the area was deemed the Dry Tortugas because although there's plenty of water around, there is no freshwater source on the islands. Water, water everywhere, and not a drop to drink!

EVERGLADES
NATIONAL PARK

I guess we're calling the largest wilderness east of the Mississippi "nothing" now.

Everglades National Park protects 1.5 million acres of subtropical wilderness in South Florida. The park is unique because it was the first time that a wilderness area was permanently protected not because of its scenery (although there's also plenty of that, in my opinion!) but to protect the diversity of life that calls this place home. Everglades protects nine distinct habitats: hardwood hammock, pinelands, mangrove, coastal lowlands, freshwater slough, freshwater marl prairie, cypress, marine, and estuarine.

The Seminole people call the Everglades Okeechobee, meaning "river of grass," and given that the Everglades contains the largest continuous stretch of sawgrass prairie in North America, that feels like a pretty accurate name for it! Also known as the sawgrass marsh, the ground here is wet for most of the year (and the name sawgrass is no joke—the ridges on the edges of the plant can actually cut you!).

These diverse habitats are home to an even more diverse array of creatures you might see on your visit, some of which aren't found anywhere else on the planet! The Everglades is home to panthers, crocodiles, alligators (the only place in the world where alligators and crocodiles live together), manatees, over 360 kinds of birds, and countless reptiles, fish, and amphibians. It's home to thirteen endangered species, and ten species classified as threatened, and is the only subtropical preserve on the North American continent.

There are really only two seasons in the Everglades—the wet season and the dry season; so you can expect tropical, warm weather no matter the time of year you visit. If you prefer milder temperatures, winter is the best time to visit the Everglades. Between December and March, the lower rainfall and humidity (relatively speaking) means you'll have fewer biting insects to contend with and milder temperatures—only about ten degrees cooler, mind you—to enjoy.

The wide range of habitats to visit also means the ways to explore them are endless. On land, you can drive, hike, bike, and camp your way through this epic wilderness. But since much of the park is water, make time

for a kayak, canoe, or boat trip if you can. For the ambitious traveler, the Wilderness Waterway is ninety-nine miles long and takes about seven to ten days by canoe or kayak, but there are many shorter paddling trails for the single-day explorer, giving you the chance to get up close and personal with all the nothing in the Everglades.

If you only have one day to spend in the park, make sure to check out the Anhinga Trail, Mahogany Hammock Trail, and Pahayokee Overlook. Much of the Everglades is designated wilderness, so if you aren't able to venture far into the park, you can still get a glimpse of the magic. Everglades is something like 99 percent designated wilderness. Even if all you have time for is a drive through the main park road, you'll still experience a spectacular view of many of the unique habitats in the Everglades. The forty-five-mile drive from the main entrance takes you through the pine flatwoods, mangrove forests, coastal lowlands, and other habitats, giving you the chance to see the many ecosystems that make up the Everglades.

TRUE RANGER STORY: A PARK THAT WHISPERS

"Everglades is not a grand park like you see out west. The parks out west scream at you, with their grand landscapes making it obvious why they became a park. Everglades is more subtle, and you have to listen carefully, because the Everglades whisper at you."

GREAT SMOKY MOUNTAINS
NATIONAL PARK

The over 850 miles of trails in Great Smoky Mountains National Park are just a bit *too* general—how is one supposed to know what to do with all this open space to explore?

Great Smoky Mountains National Park encompasses more than a half million acres of sprawling Appalachian mountain landscapes, full of streams and waterfalls, old-growth forests, and tons of wildlife. And with over eleven million visitors every year, there's plenty to keep folks of all interests occupied. Scenic roadways offer sweeping mountain views and drives through lush green forests, and over 150 trails bring you into the heart of some of the oldest mountains in the world. The Great Smokies are estimated to be between 200 and 300 million years old! Those who love fishing will enjoy the park's plentiful rivers and streams, and bird and wildlife watchers have plenty of opportunities to encounter the park's many inhabitants.

There's also plenty here for history buffs as the park has been witness to many eras of human history. Tucked into the mountains are remnants of communities that were es-

tablished here by settlers before the land was controversially reclaimed by the government to form the park in 1934. Over seventy structures are preserved in the park, which forms the largest collection of historic log buildings in the Eastern United States.

While I love for this book to be light-hearted where it can, it's also important to acknowledge the serious and darker history of these beautiful lands. The mountains were home to the Cherokee for more than one thousand years before settlers came. In the 1830s, almost 14,000 Cherokee were forced from their homes by the US government and required to move more than one thousand miles to Oklahoma. More than four thousand people died from cold, hunger, and disease during what we now call the Trail of Tears. A small group of Cherokee was able to avoid this violent removal and stayed in the Smoky Mountain area, forming the Eastern Band of the Cherokee Indians, and the Cherokee Nation remains here today. The Cherokee reservation is open to visitors, with museums and shops you can visit that celebrate Cherokee history, culture, and craft skills.

WHY ARE THE SMOKY MOUNTAINS SMOKY?

The name *Smoky Mountains* is derived from the Cherokee word *Shaconage*, which means "place of the blue smoke." If you've visited the area, you know that there is often a smoky haze nestled in the ridgelines. But did you know this fog actually comes from plants? Plants give off volatile organic compounds, also known as VOCs, which create a vapor that can form a fog at high concentrations. Since there are millions of trees, bushes, and other plants in the Great Smoky Mountains all giving off this vapor, and a high level of humidity to keep it in the air, the area has the perfect conditions to create this VOC fog. The molecules in the fog scatter blue light from the sky, creating the hazy blue tint the Smokies are known for.

Incredible hiking trails and not-at-all subpar scenery aside (I squealed with delight when I found the review pictured right that actually used the word *subpar*!), one of the best features of the park is that it's free to enter. Before the park was established, Tennessee and North Carolina jointly created Newfound Gap Road, which connects Gatlinburg, Tennessee, and Cherokee, North Carolina. When the park was established, Tennessee's conditions included a clause that stated "no toll or license fee shall ever be imposed" to travel the road, to make sure the park did not interfere with travel between the states.

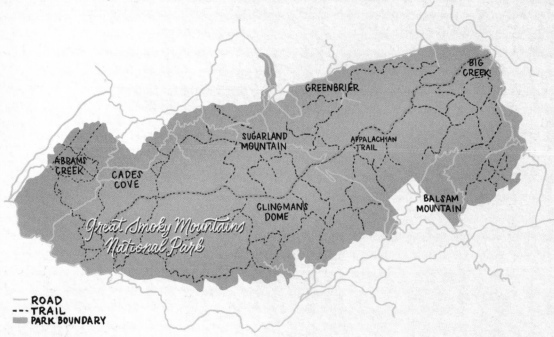

ROAD
TRAIL
PARK BOUNDARY

COLD, DARK
DAMP & STINKY

MAMMOTH CAVE
NATIONAL PARK

I know it's the longest cave system in the world, but you'd think they could get a few hundred dehumidifiers and space heaters up in here.

Mammoth Cave is a labyrinth of eroded limestone, and one of the first parks I ever visited living in the Southeast. While I don't remember it being particularly stinky, *cold*, *dark*, and *damp* definitely describe it! I remember being absolutely terrified but thrilled when the ranger turned the lights off momentarily on the tour. I don't think I've ever seen (or *not* seen, I guess!) anything so dark, and the cool, damp air around you only adds to the spooky vibes.

Over four hundred miles of the cave system have been explored, but experts estimate there could be another six hundred unexplored miles! They frequently say there is "no end in sight" to the cave system. You might think caves are only home to bats, but Mammoth Cave has more than 130 wildlife species, including the eyeless cave fish, which has adapted to the dark cave environment by no longer growing eyes.

The name *Mammoth* was first given to the cave system in the early 1800s. But some visitors will be disappointed to know that it refers to the "mammoth" size of the cave, and has nothing to do with the prehistoric mammal. *Whomp whomp.*

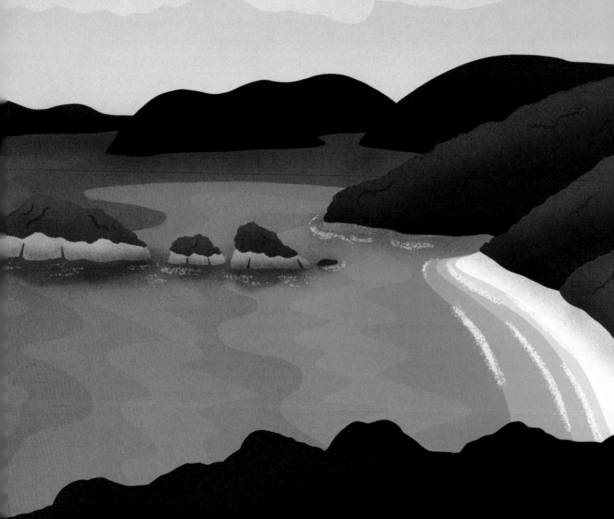

VIRGIN ISLANDS
NATIONAL PARK

US VIRGIN ISLANDS ★ ESTABLISHED 1956

There's nothing to see at Virgin Islands National Park but an overrated tropical paradise with unbelievably turquoise water. Sounds like a hard pass to me!

For most visitors, Virgin Islands' diverse beaches, coral reefs, historic ruins, and hiking trails provide endless hours of entertainment and exploration. Virgin Islands is more than just beautiful beaches, and as with most parks adjacent to water, you get the benefit of access to both land *and* water activities—the surf and turf of national parks. You can swim, snorkel, and scuba dive; sail, kayak, and windsurf; and camp, hike, and bird watch.

Hike to plantation ruins to learn about the sugar, molasses, and rum plantations that once dominated the local industries. Visit the ancient petroglyphs carved by the Taino Indians and learn about the indigenous history of the land. Snorkel through coral reefs and explore the tropical ecosystem. Or sit on the pristine beach and think about how totally overrated all of that is.

> "There is a way that nature speaks, that land speaks. Most of the time we are simply not patient enough, quiet enough, to pay attention to the story."
>
> —LINDA HOGAN

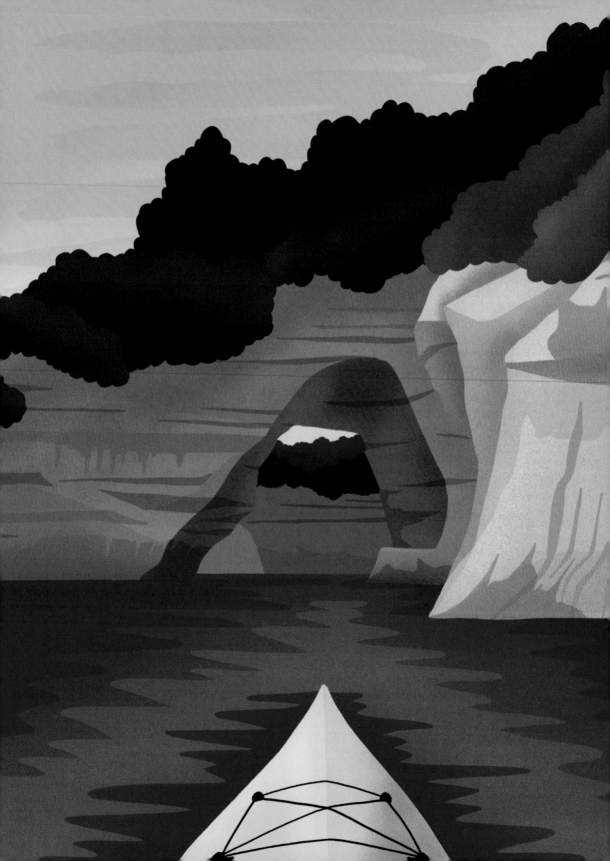

GENERAL TIPS FOR PARK VISITS

While I did a ton of research to pull the information in this book together, I'm far from an expert on the parks, and this book doesn't necessarily reflect the most current information. If you need advice on a particular park or hike, consult a park ranger or seasoned local. But I'm happy to share some general tips, which I've collected during my own visits and while writing this book, for making the most of your trip and ensuring a safe and fun visit.

KNOW YOUR LIMITS

Some parks and trails are more remote or physically demanding than others, and accessibility is often a concern. Make sure you know what level of difficulty or distance you're able to manage, and choose excursions that work within your parameters. There's more than one way to experience just about every park, but know what you're getting into ahead of time! Which leads me to . . .

DO YOUR RESEARCH AND PLAN AHEAD, BUT KEEP AN OPEN MIND

Don't be the person who shows up at Zion not realizing a shuttle is required to visit most of the park, and is now grumpy about the "unexpected" several-hour wait for the shuttle ruining your plans. Visit the park website or call ahead for up-to-date information about conditions and other things you need to know. Have a backup plan in case you find the parking lot for the hike you planned to do is totally full or a trail is unexpectedly closed.

BRING THE PROPER GEAR AND SUPPLIES

Know what you plan to do and pack what you need to do it safely! Bring plenty of water, snacks, and a first aid kit in case of emergency, and make sure to wear appropriate clothing and shoes for the weather and the activities you'll be doing. In most parks, emergency services are not quick to arrive due to their remote nature—it's your

responsibility to make sure you're being safe and smart.

MAKE FRIENDS WITH PARK RANGERS

Park rangers aren't there just to enforce the rules. They're there to be a helpful resource and make sure you have a safe and enjoyable time visiting the parks. If you're not sure if a certain activity is right for you, chat with them about what you hope to do and see if they have alternatives in mind or any other suggestions. When you're in doubt about what to do, check out the ranger-led programs in the park you're visiting!

BE RESPECTFUL OF WILDLIFE

As I've reiterated throughout this book many times, wildlife is wild! Always maintain a respectful distance (which varies depending on the animal), never feed wildlife, know how to properly store your food and toiletries if you're camping, and absolutely don't try to get a selfie with any animal. It will probably end badly for you, and then badly for the animal as well.

BE CONSCIOUS OF THE EFFECTS YOUR PRESENCE HAS ON DELICATE ECOSYSTEMS

Stay on marked, established trails—often you're walking through delicate areas that will take years to recover from even a single boot print. When you do go off trail, look for more durable surfaces to walk on, like rocks, sand, and gravel, rather than vegetation or seemingly bare soil. (The crust that forms on top of a lot of soil is a living part of the ecosystem, and your boot will destroy it. Google "cryptobiotic soil crust" to learn more.)

BE RESPECTFUL OF CULTURE AND HISTORY

Every area you're visiting has a history that goes far beyond the date it became protected by the National Park Service—nearly all land in national parks has history or cultural significance to at least one native tribe. Research and learn about the full history, place names, and culture of the land you're on, and be respectful of the often sacred sites you're visiting. Find ways to support local indigenous communities, and check out any native-led programs in or near the park you're visiting.

GET A PARK PASS IF YOU PLAN TO VISIT MULTIPLE SITES THAT CHARGE FEES

Not all parks charge an entrance fee, but many do. Research your destinations to see what kind of fees are involved and if the parks you're going to accept the America the Beautiful Pass (an annual park pass easily purchased on the NPS website). It could save you time and money to purchase one in advance of your trip.

CHECK BEFORE BRINGING YOUR PET

Many parks don't allow pets because of the delicate environments or the presence of wildlife. Make sure you know beforehand whether your pet will be allowed into the park. I can't tell you how many negative reviews of parks are because a person didn't bother to check whether their dog would be allowed on their hikes with them.

SIT AND STAY AWHILE

If there's one thing I've learned in all of my time with nature, and in talking to most rangers, it's that a great experience in a park typically doesn't happen in a few minutes. A lot of visitors are discouraged when they don't immediately see iconic wildlife upon pulling into a park or feel instantly wowed by a view. Many parks are huge, and to experience them meaningfully requires time— they're not just a page to be stamped in your park passport and then it's on to the next. The magic happens when you stop, engage fully, and really take your surroundings in.

ACKNOWLEDGMENTS

I never thought I'd write a book (and I even frequently dismissed this book as not really being "written" so much as illustrated, despite the fact that this manuscript is approaching thirty thousand words), and if I didn't have certain people in my life, I almost definitely never would have written one.

I have to start by thanking my husband, Taylor, for being my constant partner, in all things Subpar Parks and otherwise. This is the hardest thank-you to write, because it could go on for pages and pages, and no version feels like enough. He's my sounding board, my director of operations, my voice of reason, and the person who can always talk me off a ledge. He's supported me endlessly, most recently by taking over so many other tasks so that I could focus on this book.

I also need to thank my parents, who took me to my first parks and gave me the nature-loving bug. This project could not have happened without my mom, the artist, who introduced me to every craft under the sun and instilled my love of art, and my dad, who gave me my classic dad humor, love of puns, and sarcastic wit. I'm lucky to have such supportive parents who didn't really question their daughter quitting a stable job she really enjoyed because of a random project she posted on the internet.

I'm also grateful to my mother- and father-in-law, who have known me for more than half my life and treat me like a daughter. They are incredibly supportive and always willing to offer a helping hand, including by spending a week helping with Subpar Parks calendars after I dislocated my elbow at the end of 2020. I wouldn't have gotten through this past year without their support.

I'm forever grateful for my friend Mallory, my tentmate and my fellow entrepreneur, who pushes and inspires me to strive for more (while also reminding me to celebrate my wins and take a damn break). She's reviewed just about every illustration and Instagram caption for me throughout this project and never tires of it, at least not that she lets on. I don't know that I would have had the courage to pursue my own business if not for her. I also need to thank my friend Jess, my OG travel buddy, without whom I would not have survived Scotland and wouldn't have had the guts to explore and travel as much as we have together. She's the organized yin to my chaotic yang, and a lifelong friend who is absolutely always just a phone call away, no matter what, and I'm

beyond lucky to have her. Both of these women are there at the drop of a hat for me, and I'm eternally grateful. People blame social media for a lot of bad things, but I met both of them on Facebook, so at least two good things have come out of it.

I'm also grateful for my friend Laura, who always believed I was destined for big things. We may not always be at the forefront of each other's lives, but I wouldn't be where I am today without her cheering me on over the years, even when I didn't believe in myself.

I'm thankful for my friends, family, teachers, bosses, colleagues, and fellow artists and designers who have pushed me creatively, inspired me with their own work, and supported and cheered me on, without whom I would never be the artist I am today. I can't name them all here, but you are an important part of who I am. Thank you.

I want to extend a huge debt of thanks to the park rangers, volunteers, and local experts who offered me tips, knowledge, and anecdotes about the wonderful places featured in this book: P. Dandenault, A. Andreas, Tasha Cathey, K. Rohrberg, J. Schamble, H. McPherson, Callie Johnson, Emma Partin, B. Eckert, K. Baker, Joshua Contois, D. McDermott, S. Cohen, P. Winfrey, and those who preferred not to be named, and to Kim Hirose at the National Park Foundation, who encouraged me throughout this project and offered herself as a resource to me.

I'm so grateful for the teams at Aevitas Creative Management and Plume—Kate, Justin, and Jill especially—who helped me push this project even further, never questioned whether I could actually write a book, and without whom this would probably be a simple collection of illustrations because I would have been far too afraid to do anything else.

And finally, though this is an incomplete list, I'd like to thank content creators like @alex_pi3, @indigenouswomenhike, @laura .edmondson, and @hownottotravellikea basicbitch on social media for offering their knowledge and experiences as educational resources on important topics like native land history, indigenous relationships with our parks, and the perspectives of BIPOC individuals in the outdoors. They always inspire me to be open-minded, to be ready to learn, and to do more research.

 RESOURCES

Feeling inspired to plan your next trip to a new park, or looking to get involved in the parks or just learn more about them? There are tons of wonderful resources online, but here are a few to get you started.

General Information, History, and Safety

Information about Individual Parks, Activities, Current Conditions, Etc.
> www.nps.gov

Annual Park Passes
> www.nps.gov/planyourvisit/passes.htm

Recreate Responsibly
> www.nps.gov/planyourvisit/recreate -responsibly.htm

Search by Parks and Activities
> www.findyourpark.com

Indigenous History, Culture, and Land Acknowledgment

These links may help you start to understand the historic and modern Native nations in the United States, but remember, you can also just google "indigenous tribes/history of _____"!

Tribal Leaders Directory (This site does not reflect historic land claims)
> www.bia.gov/bia/ois /tribal-leaders-directory/

Native Land Map (I suggest doing additional research, as this map is not always completely accurate)
> www.native-land.ca

Visiting with Children

Every Kid Outdoors
> www.everykidoutdoors.gov

Junior Ranger/Junior Angler Programs
> www.nps.gov/kids/parks-with-junior -ranger-programs.htm

Tips from Rangers
> www.nps.gov/articles/visiting-national -parks-with-kids.htm

Get Involved or Donate

National Park Foundation
> www.nationalparks.org

National Parks Conservation Association
> www.npca.org

Public Lands Foundation
> www.publicland.org

Volunteer Opportunities
> www.nps.gov/getinvolved/volunteer.htm

Partnership Opportunities
> www.nps.gov/subjects/partnerships /partner-with-us.htm

Careers
> www.nps.gov/aboutus/workwithus.htm

ABOUT THE AUTHOR

AMBER SHARE is an illustrator and graphic designer based in Raleigh, North Carolina. She graduated from the University of Nebraska in 2010 with a degree in advertising and a minor in art. After several years as a professional graphic designer working on hand-lettering and illustration on the side, she left her job in graphic design to pursue illustration full time. As an avid hiker and backpacker, she spends a lot of time in local, state, and national parks, which inspired this project and this book.